Who's Who in Kentucky Arts and Crafts©

2007 Annual Edition

By Arlene Wright-Correll

An Annual Yearbook of Kentucky Artists and Crafters

Here you will find every type of KY artist and crafter interviewed in 2007, discover their art; learn about them and how to locate them.

This book is dedicated to all the Kentucky artists and crafters who made this work possible. Thanks for giving me your time and information to share with others and we wish you great sales!

ISBN-978-0-6151-8494-4

Publications Trade Resources Unlimited

100 Dave Wintsch Rd., Munfordville, KY 42765

(270) 524 9567

Copyright 2007

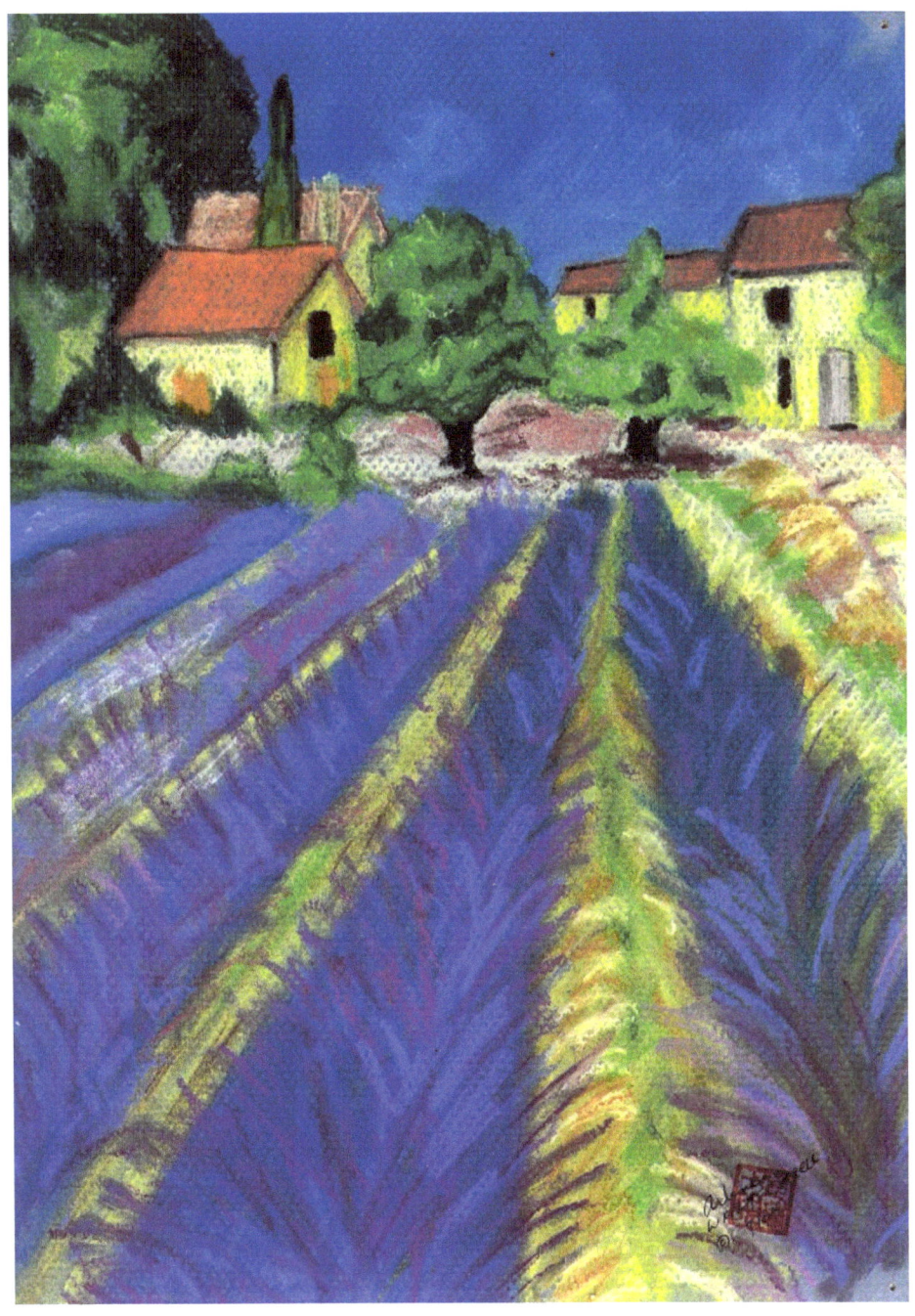

Front cover by Arlene Wright-Correll
"Lavender Fields II©"

You can invest in a Giclee print of this original for as low as $16.95

http://arlene72.imagekind.com/ArlenesMediterraneanSeries

This book is dedicated to my son, Donald Wright, who gives me pleasure knowing him.

About the Author & Artist. Arlene Wright-Correll (1935- ___), popular American award winning Artist, author and avid gardener, at the age of 68, decided to pick up her paint brushes again after 54 years and paint, in mostly gouache watercolors and pastels, the flowers, herbs and fruits that grow at Home Farm Herbery in Munfordville, KY.

Though she paints in all mediums, she likes to use the Gouache paints, which are a heavy, opaque watercolor paint, sometimes called body color, producing a less wet-appearing and more strongly colored picture than ordinary watercolor. Occasionally, she will paint something from her world travels especially of Scotland, Ireland, or the Mediterranean. She is fond of those old memories. She is the resident artist and workshop instructor at Avalon Stained Glass Studio. She is also a **certified South Central KY Arts and Crafts Guild artist,** a **Certified EBSQ artist** and a **nominated member to The Museum of Women's Art** in Washington, DC. Ms. Wright-Correll is the creator and writer of **Who's Who in KY Arts and Crafts** and a member of **KAHT. Exhibitions:** Western KY University Celebration of the Arts, 2007 & South Central KY Cultural Center, Glasgow KY, 2007, Artist of the Month, Horse Cave Book Store, 2006, 1st place winner Salis International, Colorado Springs, May 2005. Hydras Watercolors.

Her original paintings are sold quite quickly and one can always try and pick up whatever current one she is working on. The amazing thing about this "young" artist is that as a mother of 5 & the grandmother of 5, she is also a cancer and stroke survivor who is able to strive forward each and everyday to welcome the beauty of this small planet.

She is also a China & Porcelain painter, Stained Glass Artisan, Works in Fused Glass and Encaustic Art. She is one of the six KY Artists who worked 6 months to create the dolls for Journey Jots in 2006. Her favorite motto is a quote by Ruth Smelter., "You have not lived a perfect day, even though you have earned your money, unless you have done something for someone who cannot repay you."

"Tread the Earth lightly" and in the meantime.. May your day be filled with… **Peace, Light and Love,**

Arlene Wright-Correll
NOTICE: I retain the copyright, licenses and reproduction rights on all my work.

To see more of her work visit Avalon Stained Glass School, Studio & Art Gallery
100 Dave Wintsch Rd. Munfordville, KY 42765
Tuesday – Friday 9 to 5, Saturday 8 to noon
www.learn-america.com (270) 524 9567

Please check their site often. New paintings are being added all the time.
Or go to www.learn-america.com/stories/storyReader$158

Directions to studio: from Munfordville Courthouse go North on 357 for 2 miles, Right onto 2185 for 3..3 miles, Right onto Dave Wintsch Rd. and we are the 1st driveway on the left. Visit us for a FREE demonstration.

Who's Who Kentucky artist Susie Hardin

Textile artist Susie Hardin, a native of Michigan, moved to Bowling Green, KY 2.5 years ago when her husband, Joe Hardin became a director of one of the departments at the college.

Susie is a self taught textile artist with a few years of college and she has been creating and selling beautiful works of fabric art for 25 years. She does silk painting on silk using special silk dies. She paints by hand and uses wax as a resist generally working in a batik style.

Batik is a Javanese word that refers to a generic wax-resist dyeing technique used on fabric. The word comes from the Javanese word "amba", meaning "to write", and the Indonesian word for dot or point, "titik".

Melted wax is applied to cloth before being dipped in dye. Wherever the wax has seeped through the fabric, the dye will not penetrate. Sometimes several colors are used, with a series of dyeing, drying and waxing steps. Thin wax lines are made with a *tjanting* (canting, pronounced *chahn-ting*) needle, a wooden-handled tool with a tiny metal cup with a tiny spout, out of which the wax seeps. Other methods of applying the wax to the fabric include pouring the liquid wax, painting the wax on with a brush, and applying the hot wax to a precarved wooden or metal wire block and stamping the fabric. One indication of the level of craftmanship in a piece of batik cloth is whether the pattern is equally visible on both sides of the cloth. This indicates the application of wax on both sides, either with the canting or with mirror-image design blocks.

After the last dyeing, the fabric is hung up to dry. Then it is dipped in a solvent to dissolve the wax, or placed in a vat of boiling water, or ironed between paper towels or newspapers to absorb the wax and reveal the deep rich colors and the fine crinkle lines that give batik its character.

Painting and dyeing with fiber-reactive dyes involves 3 stages which includes the absorption of the dyes in the fabric, the fixing of the dyes in the fabric, and the rinsing of the superfluous and not fixed dye-stuff.

Living all over the country Susie has been able to pick up the nuance of colors and shapes from her travels. Besides the silk painting, Susie is an excellent and gifted artist of art quilting with each piece being a brilliant and colorful work of art interweaving the color of the fabric, the texture with the stitching of the quilt. However, the item that really entranced me was her fabric post cards. These can be used to mail through the U.S. Postal system, but who would want to as each is a work of art unto itself, with no two being alike and suitable for framing.

There is a great sense of femininity to Susie's accessories and the brilliance of colors and the unique designs, plus the very affordable prices creates wearable art that any gal with élan cannot pass up. Susie Hardin will set you guys up with a private appointment at her home studio thus allowing you the distinction of being able to purchase the most unique and upscale gift this year for that special someone in your life whether it be mom, wife or sweetheart for any occasion.

So call her at 270 796 4820 in Bowling Green, KY and you will be glad you did.

Who's Who Kentucky artist Philip H. Holder

Philip H. Holder is a native of Barren County, KY and lives in Austin, KY where he lives in the home he grew up in. He says he was 2 years old when he started to paint and has been prolific ever since. He has a home studio where he paints art that leans towards fantasy and surrealism and is very much reminiscent in the style of Salvador Dali. Frankly this writer prefers what she viewed of Philip's work to what she has viewed of Dali's. His preferred mediums are color pencil and acrylics.

Surrealism is a movement stating that the liberation of our mind, and subsequently the liberation of the individual self and society, can be achieved by exercising the imaginative faculties of the "unconscious mind" to the attainment of a dream-like state different from, or ultimately 'truer' than, everyday reality.

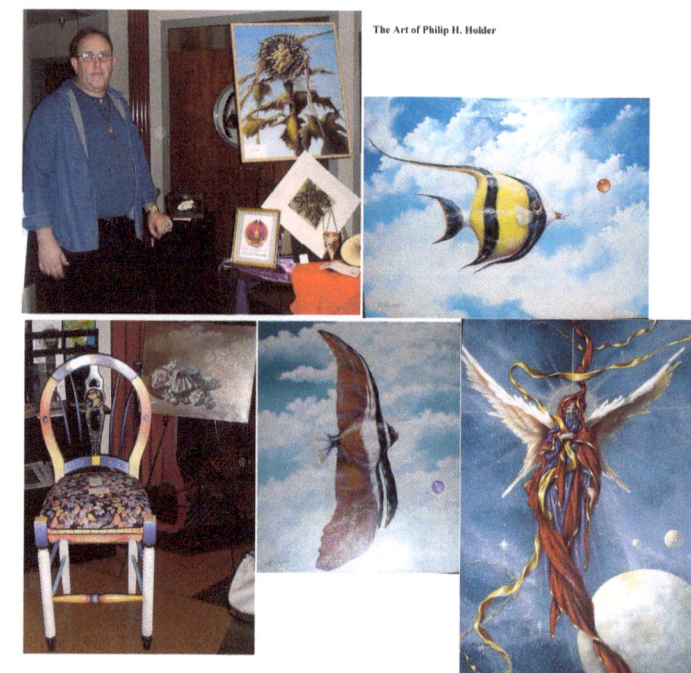

Surrealists believe that this more truthful reality can bring about personal, cultural, and social revolution, and a life of freedom, poetry, and uninhibited sexuality. André Breton said that such a revealed truth would be beatific, or in his own words, "beauty will be convulsive or not at all."

In more mundane terms, the word "surreal" is often used colloquially to describe unexpected juxtapositions or use of non-sequiturs in art or dialogue. When the concept of surrealism has been "applied" by associated groups of individuals, it has often been called a "surrealist movement," whether cultural (including artistic) or social. Philip studied under S. V. Rama Rao, from India and he said the students called his course, "Ulcer 101" because he was such a harsh teacher. Philip's artistic talents, beside producing fine art includes doing murals, trompe L'Olel and Faux Finishes on furniture. He had an exciting chair he had done over.

Trompe-l'œil (French for "trick the eye" from *tromper* - to deceive and *l'œil* - the eye; and is an art technique involving extremely realistic imagery in order to create the optical illusion that the depicted objects really exist. Although the phrase has its origin in the Baroque period, use of trompe-l'œil dates back much further. It was (and is) often employed in murals, and instances from Greek and Roman times are known, for instance from Pompeii.

Philip will do commission work using any of the above techiques on any piece of furniture you want to turn into something different and exciting or he will come and do that mural you finally have been thinking of for your home or business. Using the Trompe L'Oeil technique Philip can turn a real dull part of your home into an intriguing and exciting art area.

Do give him a call at 270 646 2455 to come to his home studio at 2271 Austin, Boatramp Rd., Austin KY 42123.

Who's Who Kentucky artist Carolie Booth

Carolie Booth was Decatur, Indiana's loss when she moved to Fountain Run, KY. Carolie is an active member of the Scottsville, KY Art Club and her acrylics and oil paintings prove the reason why she has won numerous awards over the years.

Not only does Carolie work in these two mediums, over the years she has worked in ceramics and in the art of china or porcelain paintings.

About 10 years about Carolie decided she would take painting up as a hobby and though these years she has strived for improvements, not perfection.

She says, "The best thing about her paintings is that she can depict animals and/or landscapes while trying to convey to the viewer the majesty of God's creation."

Well, this writer has seen her work and believes that Carolie often achieves her goal. One can contact Carolie at 270 524 3434 to view and purchase any of her original works.

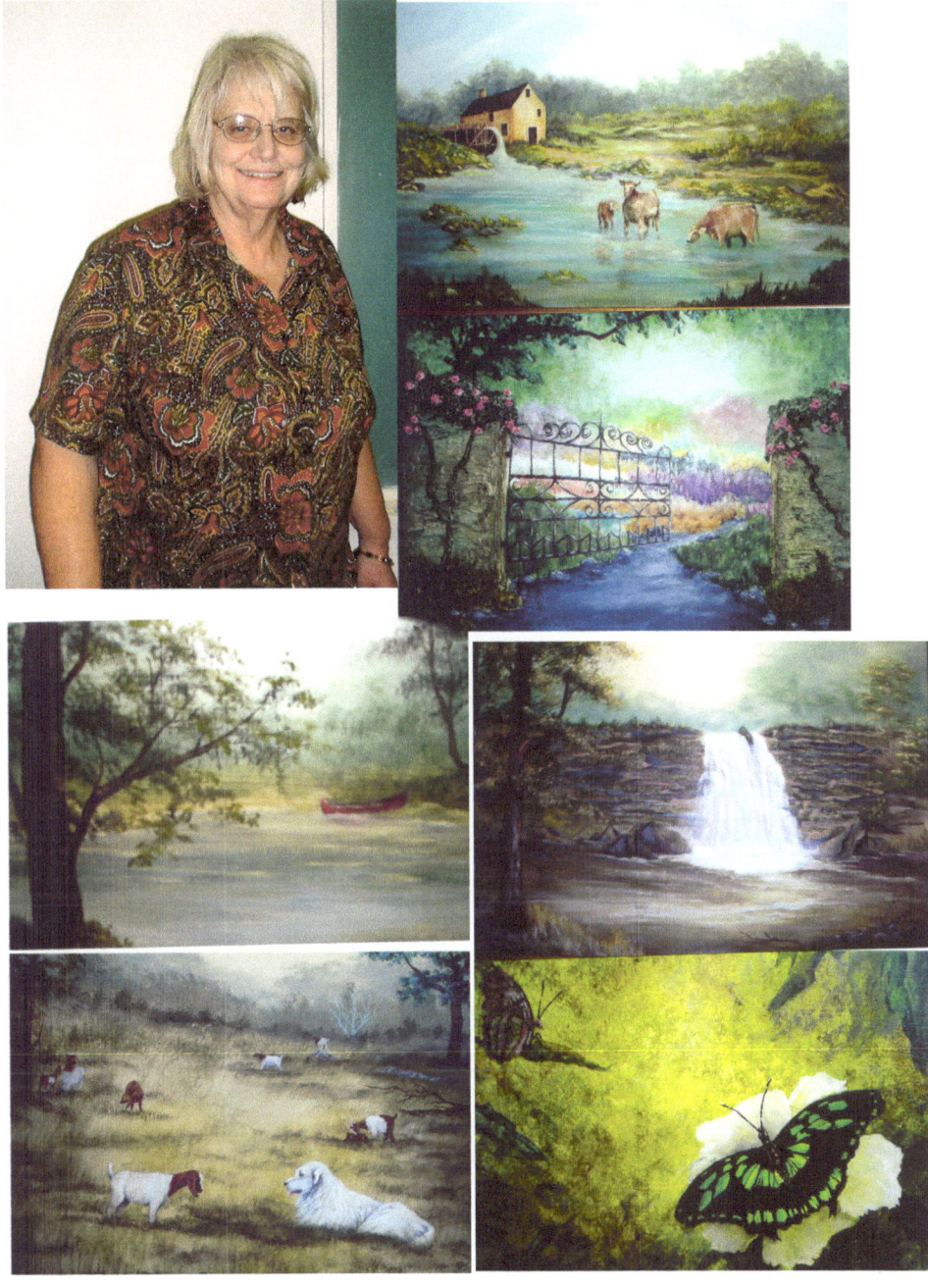

Who's Who Kentucky artist Regina Carter

When I started this column I thought any minute I am going to run out of people to write about. Yet here again is another amazing person who quietly lives over in Scottsville, KY painting away.

Regina Carter is a native of Pennsylvania and about 1.5 years ago she decided to take up

**Regina Carter
Scottsville Artist**

painting. Always creative, Regina is also a quilter and a basket maker. She is also a member of the Scottsville Art Club.

Regina says, "It is always amazing to watch the colors come together whenever I paint a picture and so see the end results".

Regina can be reached at 270 622 5967 regarding any of her creative art efforts.

Who's Who Kentucky artist Katie Kelley

When one thinks about pride in accomplishment one immediately thinks of Katie Kelley. Katie, a native of Gaston, IN lives in Scottsville, KY with her artist husband, Jim.

For over 16 years, Katie has been creating works of art in oil and acrylics. The two paintings shown here reveal her talent in bringing out the personality of her subjects.

Again, this artist is a member of the Scottsville Art Club which seems to abound with award winning artists of which Katie Kelley is one.

Anyone interested in contacting Katie about her works of art can do so by calling her at 270 622 8343.

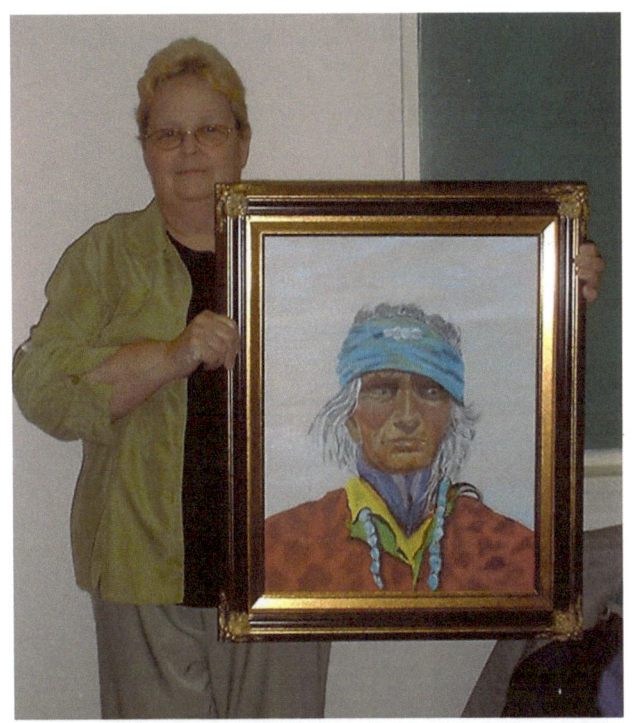

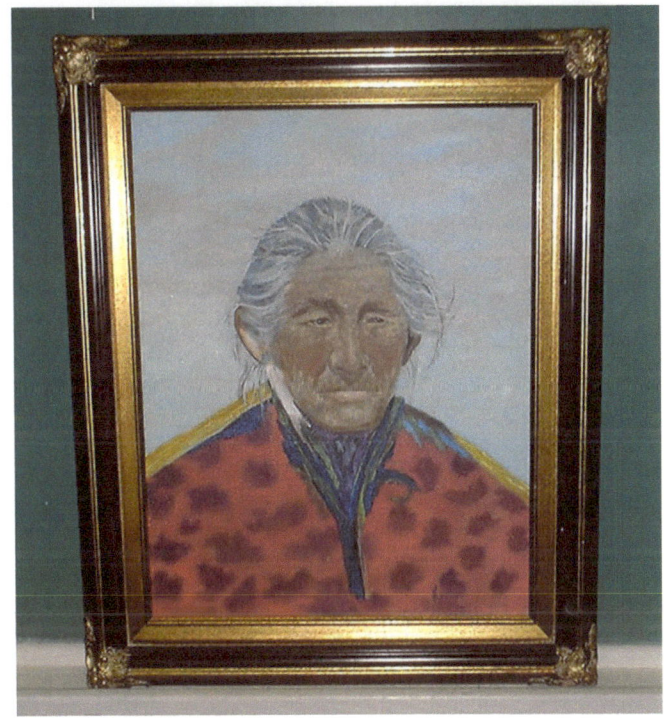

Who's Who Kentucky artist Emmy Houweling.

Emmy Houweling is a native of the Netherlands and she is a self taught Primitive Folk Artist who resides and works out of her historic 1820's home in New Castle, Ky. Inspired by an 18th century Dutch itinerant folk artist, she has been creating art throughout her entire life and began working with paint 30 years ago just by "doodling around" as she says. Emmy decided in 1995 to become a professional painter and has since characterized her style by using black backgrounds and signing her work with: Emmy (fish) .

Emmy does a lot of commission work and puts the subjects in the paintings of their working farms and weathered barns to familiar buildings that lay sideways, each painting tells her story with movement and accomplishment. These primitive rural works of art definitely cannot be categorized as "still life". They represent common people, performing life's everyday tasks, with whimsical animals grazing and working the lands on which they are so lovingly featured.

Emmy has exhibited her works extensively and accepts commissioned work to paint local farms and homes. She is a professionally affiliated member of many of the Arts and Craftsmen Guilds and participates, year round in many Juried Art Fairs and exhibits in Kentucky, Indiana, Georgia, Ohio, Illinois, and Alabama. Many of her creations have traveled across the United States, and to England, Australia, France, Germany, Romania, the Netherlands, Greece and most recently to Chile. She also takes time to teach children's art classes out of her home studio.

Emmy's professional affiliations include Henry County Arts and Craft Guild, KY, Juried Member Louisville Artisans Guild, KY, Juried Exhibiting Member KY Guild of Artisans and Craftsmen, Member Louisville Visual Arts Association, KY, Member Oldham County Arts Association, KY and Visual Arts at the Market/KY Crafted, a Program of the KY Arts.

Emmy's Past Exhibits include Water Tower Art Museum, "2001 Annual Exhibit" Louisville, Actor's Theater Lobby Exhibit, Louisville and Pegasus Gallery at the Louisville International Airport. She has also exhibited in "Bank One Exhibit" 2002 Louisville, KY State Capitol Building, Frankfort, KY, Terrace Gallery, JCC, Louisville, KY and Louisville Stoneware, Louisville, KY, Solo Exhibit.

Emmy participates, year around, in many fine Juried Art Fairs and exhibits and her special awards and accomplishments include First Place Cash Award" 2-D category in 2002 Oldham County Arts Association, First Place Cash Award" 2-D category in 2003 Oldham County Arts Association, Cover Page "Country Register Publication", Huntington Museum of Art Hilltop Festival 2003 Poster, 2004 Calendar Page - Louisville Visual Arts Association just to mention a few.

Several of her paintings have been selected and purchased by the *Brown-Forman Corporation* for their Arts Collection at the Corporate Offices in Louisville, Kentucky and many commissioned work for private Homes, Farms and Horse Farms in Kentucky and Indiana

Currently Emmy is part of an artist co-op called Gallery 1070 which is in the Melwood Arts and Entertainment Center in Louisville, KY. She has a website called http://www.emmysart.com and at either place you can buy her art, prints or note cards.

Who's Who Kentucky artist Katherine Allen

Arriving at the grand age of 87 has not stopped Katherine Allen of Scottsville, KY from doing what she loves best. A native of Glasgow, KY Katherine says she began to draw as soon as she was able to hold a pencil and began to paint at the age of 15.

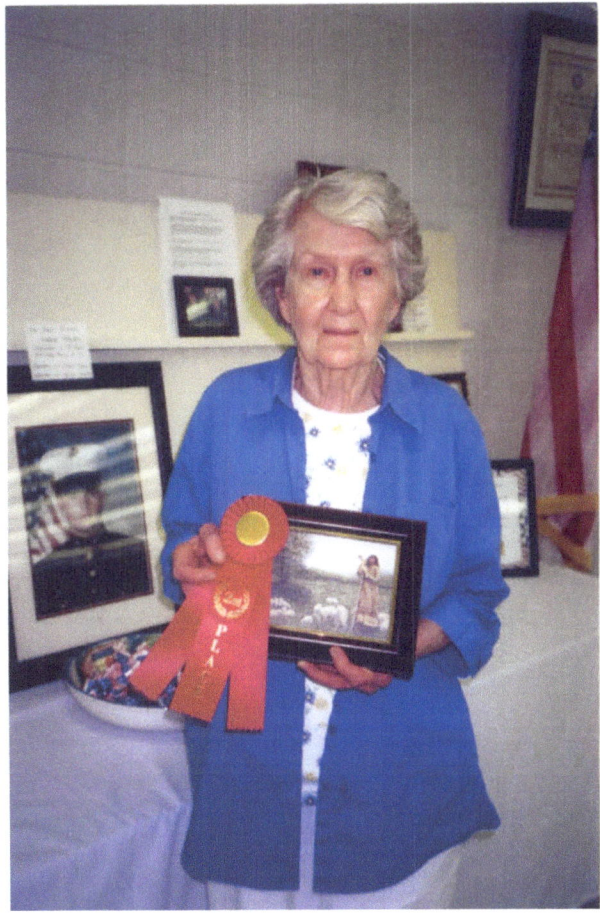

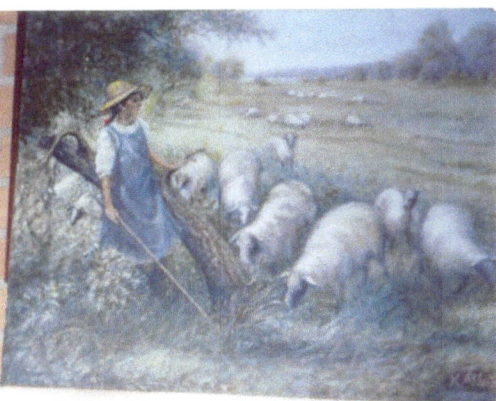

Katherine is a mixed media artist and works in oils, acrylics, watercolors and pastels.

Her sheep pictures took the best of the show in 1997 and Best in Acrylics and the People's Choice award.

Katherine, though an artist considers motherhood another one of her accomplishments. She says both things make her feel natural and she is an encourager in both.

When I asked her what her special thoughts were about painting, she immediately replied, "It makes me feel good!"

Many of her paintings are done for different people at their request and many she keeps at home. She can be reached at 290 237 4453 should you wish to commission her to do a painting for you.

Who's Who Kentucky artist Lydia Wellman

Lydia Wellman is an award winning member of the Scottsville Art Club and she lives in Glasgow, KY. A native of Germany she is creative not only in acrylic and watercolor painting, but also in photography.

She has been a photographer for 30 years and decided to do something with all those photos she has. About 5 years ago she chose some she liked and used them as the basis for the paintings she painted in acrylics. Then a little over a year ago, Lydia decided she would like to try her hand in working with watercolors.

This writer has a premise that artists, who keep trying other mediums, even briefly, are artists who expand their minds and their talents and Lydia is living proof of that premise.

When I asked Lydia what she liked best about the painting part of her business, she replied, "I have lots of photos and when I die they will probably be all thrown away, so I paint them and hope the paintings will live on.

Lydia's advice to other artists is, "Paint with other's because it is inspiring and perhaps you will get inspiration also."

For Lydia Wellman "painting is an escape." So if you want to see her work, just give her a call at 270 678 9715 and perhaps be inspired to find your own escape from every day life.

Who's Who Kentucky artist Evelyn Law

Evelyn Law is a native of Allen County who lives in Scottsville, KY and is an active member of the Scottsville Art Club and she has had exhibitions in KY, TN and North Carolina.

Evelyn's Medias are oil, acrylics and watercolors.

She began painting in 1979 and had her first show at the library in 1981.

She taught art classes for about 10 years until she began to lose her vision.

Though not formally trained in art, Evelyn has the distinction of having her art hanging in 16 states and she also has 6 people who have art collections of her work.

Though she lost her central vision to Macular Degeneration she still has some peripheral vision left and she is still painting. Evelyn says her style can be called "very impressionistic!"

Painting allows Evelyn to lose herself in whatever she is painting whether it is the beach, mountains or her old home place.

This award winning artist has 27 years of creative activity and we love the fact that she is still going strong. Her work is for sale and you can call her at 270 622 4592 to view and purchase it.

Who's Who Kentucky artist Thelma Williams

"Since I have been doing art, it has opened a whole new world to me. I see clouds, trees, and the whole world differently!" These are the words of Scottsville award winning artist Thelma Williams.

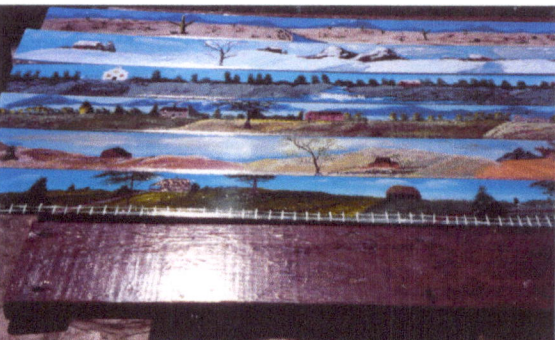

Those of us who paint understand exactly what Thelma means. One does not look at trees and just see trees; one sees all the colors of each leaf, all the colors of the bark. Try looking at a tree next time to see what Thelma means.

The paintings I saw created by Thelma have proved that. She paints in oils and acrylics and she captures the shade and hues of her paints exceedingly well.

She has been painting since 1989 and the best thing she likes about painting is that it is a great stress reliever and that the finished product proves to her that she can do something.

Again those of us who paint understand exactly what Thelma is saying. One becomes immersed in what one is doing when one relaxes and just paints! Thelma is a member of the very active Scottsville Art Club.

However, one of the amazing things about Thelma is the one of a kind painting she will create. Though she paints on canvas, she also paints on top of window blinds! They are amazing to say nothing of being unique. She can be reached at 270 618 4430 to view her work.

Who's Who Kentucky artist Jim Kelley

This writer knows many wood carvers. However, this is the first time I have met and interviewed a wood carver like Jim Kelley of Scottsville, KY. Jim a native of W. VA retired from Doug Warner Automotive Industries in Muncie IN. He is a member of the Scottsville Art Club.

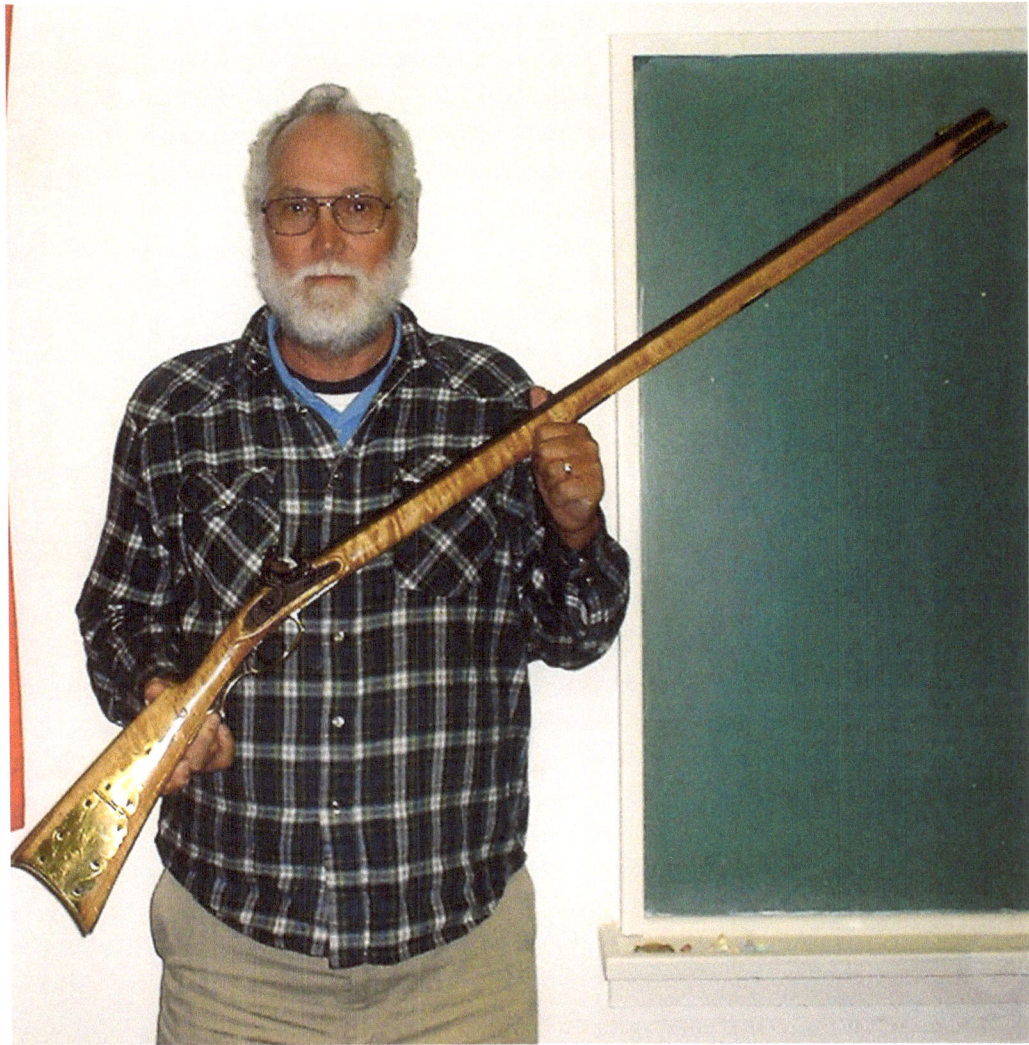

He has been a wood carver for the past 20 years. So what does he carve?

Old Muzzle Loader Rifles; 1400-1600 vintage rifles that actually shoot!

Jim never uses any power tools. All his work is done with hand tools in his home workshop and each rifle takes several hundred hours to create and finish. He hunts for his wood in TN, Ohio, and PA and VA thus making each rifle he creates a true labor of love.

Anyone interested in commissioning one of these rifles can contact Jim at 270 622 8343.

Who's Who Kentucky artist Lorie H. Short

When you are the People's Choice, you are the People's Choice and Lorie H. Short, an Allen County native who lives in Glasgow, KY proved that by winning the 2005 People's Choice Award at the Summers End Art Show, 2005 People's Choice Award in Glasgow, John Wings, Community Ed. Art classes and 1st place Professional Acrylic 2006 Summer's End Art Show.

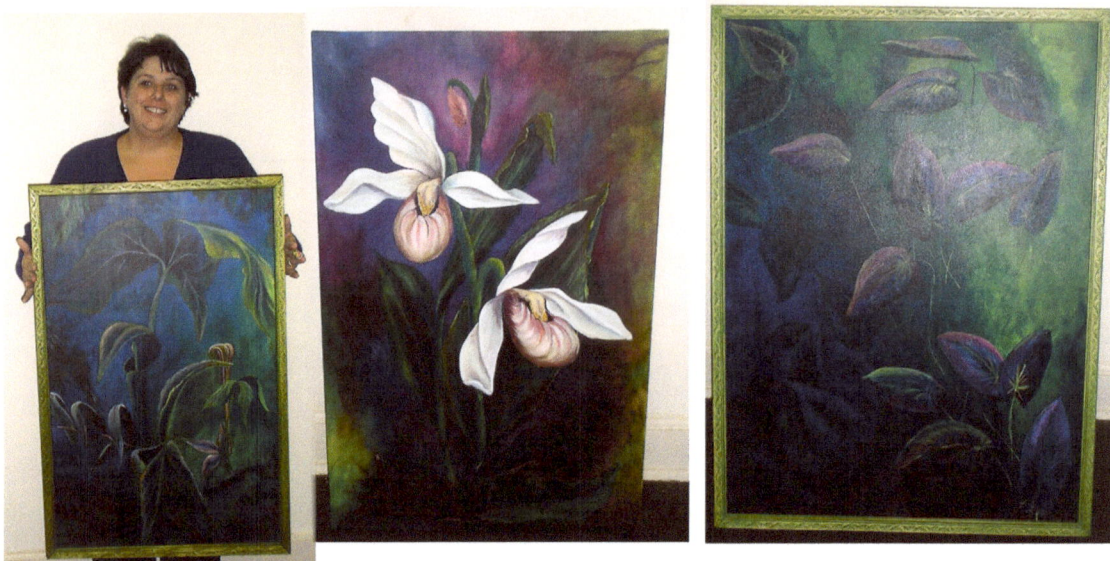

One would think it might take a lifetime of painting to be a Triple Crown winner, but Lorie has only been painting for 3 years. She love acrylics because they dry fast and are odorless.

The fast drying allows Lorie to change things about the composition or colors whenever she changes her mind. She says, "When it's clicking, I'm humming or singing."

Lorie is a member of the very active Scottsville Art Club which seems to be teeming with award winning members.

To view any of Lorie's vibrant, large works of art please call her at 270 646 3479.

Who's Who Kentucky artist Marsha L. Holm

There is much to say about photography as an art. The photographer is allowed not artistic license through the lens of the camera except what his or her mind conceives the subject shall be. They must decide whether or not the subject is the grand scale of what they are viewing or just a small section of it. One such photographer is Marsha L. Holm.

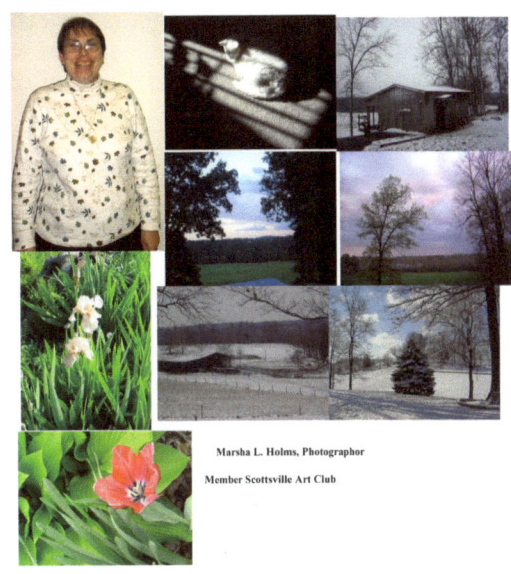

Marsha L. Holms, Photographer
Member Scottsville Art Club

Marsha moved from Orlando, FL to Scottsville, KY in February 2005 with her husband Gary. She is a photographer and she says this is the sixth state she has lived in. She and her husband love to travel by train and Corvette and so far had been to 43 states with a goal of traveling to all 50 states and Canada. Those plans abruptly stopped when Gary passed away in February 2006 after living together for 24 year. During 20 of those years Marsha worked in an office doing many things including bookkeeping and then owned 2 of her own businesses before moving to KY.

She says her passion for photography began at the age of 16 her great uncle gave her a little Brownie camera that only used black and white film. With her great love of color she had to get a camera that used color film and that was her second camera which was a little Kodak point and shoot that took the 126 film. By this time she was married and Gary saw how much she loved taking pictures so he bought her a top of the line Nikon point and shot with a 28-8- zoom. Soon she outgrew that and Gary bought her a SLR Nikon N50 and finally a Nikon N90S with all the bells and whistles that go with it. About 3 years ago Marsha acquired her first digital camera, a Sony Cyber-Shot P-92 5 MP.

Though she and Gary never had any children, they do have a large extended family and circle of friends and for the last 20 years Marsha has created a family calendar each year which contains family pictures. Since 1998 she has been able to include the pictures from the annual Christmas reunion. She also has many photos that she has taken though out the years of their travels and these include landscapes, flowers, trains, cars, architecture, family and friends.

Her other hobbies include graphic design, scrap booking and crafts and she is a member of the Scottsville Art Club. Marsha says, "My art is photography. Flowers, landscapes and nature are my favorites to photograph. I love capturing just a little piece of God's fingerprint, whether it is in a flower, landscape, animal, person's face or expression. I also love when my pictures touch someone's emotions."

Marsha has had some of her photos published in books. She says, "It's is amazing to see your name in a book under a picture as the photographer. I have also won 2nd place in a cultural arts completion. My ultimate goal is to become a professional photographer and enough of my photographs to make a living."

Marsha also belongs to a camera club and you can also see some of her work on their website. www.sunny16club.com .

Marsha is available for photo commission work and her contact information is Marsha L. Holm. 868 Bays Ridge Rd., Scottsville, KY 42164 (270) 618-6560 Home (407) 579-3860 Cell email holmhsd2@earthlink.net

Who's Who Kentucky artist Angela M. Arnett

Angela M. Arnett is a juried artist who lives in Shepardsville, KY and is affiliated with the Louisville Artisans Guild, the Kentucky Craft Marketing Program, the Kentucky Guild of Artists and Craftsmen in Berea, and the Bullitt County Art Council. She has a rich Native American heritage and is the sixth great granddaughter of the last great Chief of the Cumberland Plateau Region, Chief Talsuska Chiqualatuque. She creates work under the name of Blue Moon Art and she has been doing this kind of art work for 10 years now.

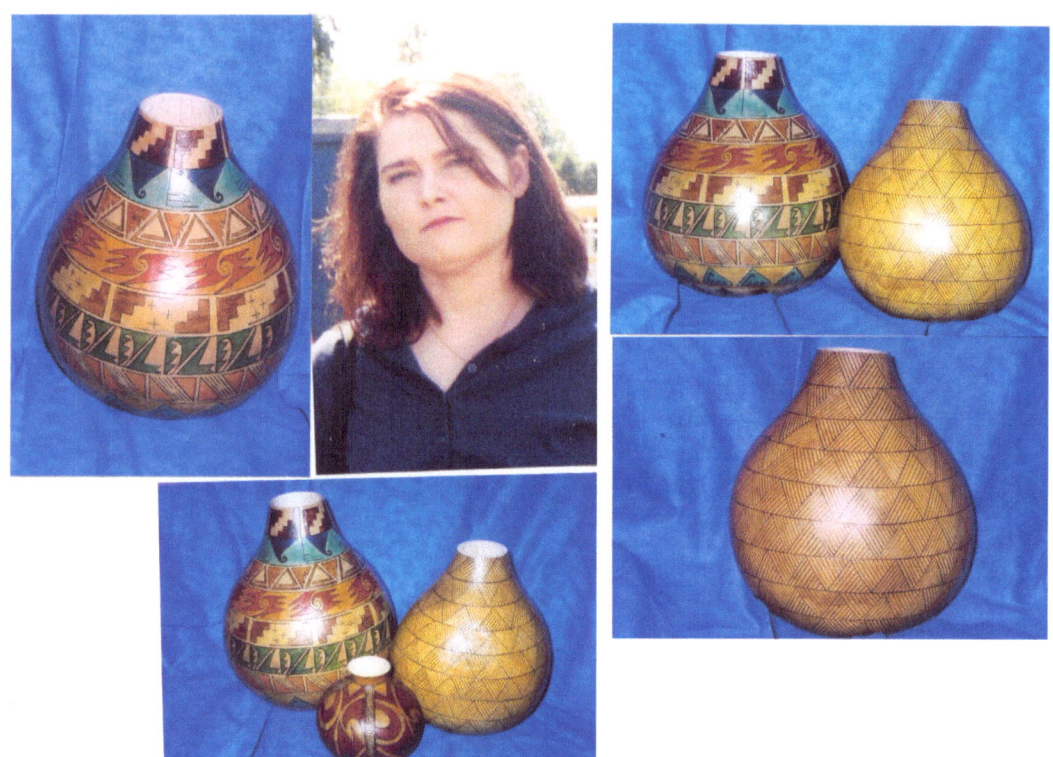

Many people paint or decorate gourds; however, very few have the historical background to bring our heritage of their decorations. Angela helps to celebrate this rich heritage every day by creating gourd pots, bowls, and jewelry with intricate, beautiful traditional geometric designs that have been utilized in Native art for centuries. Not only does she paint these, she also hand burns (pyro-engrave) beautiful scenes of Native life, communities, campfire celebrations, dances, everyday life onto and into these gourds.

Her work can be found in galleries across the state, including the Kentucky Artisan Center in Berea, the Kentucky Museum of Arts and Crafts in Louisville, the Bernheim Forest Gift Shop in Clermont, and the Salt Box Gallery in the Shepherdsville Tourist and Convention Center.

You may buy directly from Angela or see her work at her studio by calling 502 543 8014.

Who's Who Kentucky artist Gloria Kemper-O'Neil

Gloria Kemper-O'Neil lives in Louisville, KY and is a Fiber Artist who designs and creates non-traditional wall hangings. Her present creations evolved over a period of years as she had been working with clay, making Goddesses with fiber hair and exotic clothing.

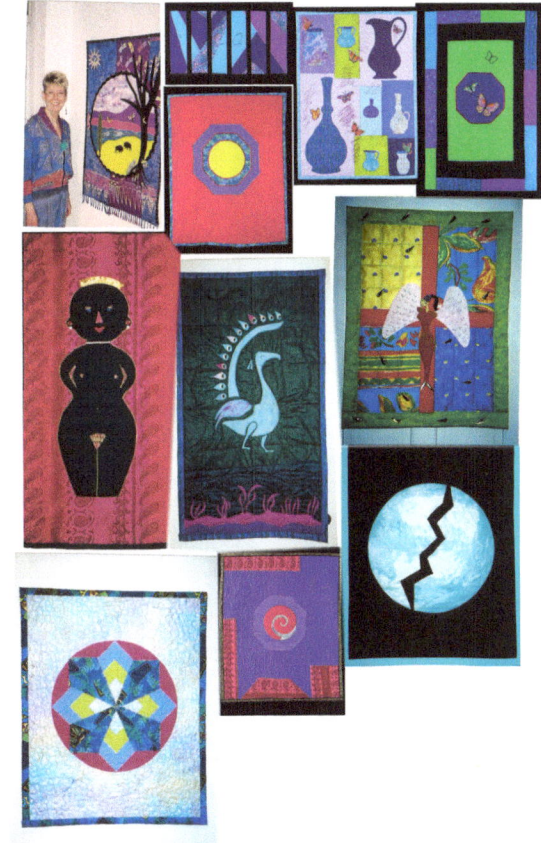

For the past six years she has been working exclusively as a Fiber Artist. She creates machine embroidered and machine quilted wall hangings. Some are embellished with beading. She says inspirations for many of her designs come to her in dreams and many feature Goddess figures.

Her love for sewing came to Gloria from her grandmother who taught her how to sew on her Singer treadle sewing machine and also how to embroider. Now that Gloria is also a grandmother and a retired RN, as well as a Fiber Artist she sews on a state-of-the-arts electric sewing machine and a giant long arm quilting machine. Her work embodies female energy, images, abstracts, shapes and colors that inspire me. She enjoys exploring, breaking the rules and being open to the unexpected. This freedom brings about many surprises!

Gloria has had an annual Art Show for the past five years and her work has been in some of the top juried shows nationally and on exhibit in regional and local galleries. A number of her pieces are in private collections around the country. She says, "When I am doing my art I am dancing a sacred dance." In her free time she enjoys golfing and mountain hiking and she also does daily yoga. Her awards are as follows:

Honorable Mention, for "Kuan Yin", 13th Juried Art Exhibit 2006, Krempp Gallery, Jasper, IN
1st Place 2-Dimensional, for "Tribal Woman", 2004 NWMF Juried Fine Art Exhibit,
Ohio State University, Columbus OH, Honorable Mention, for "Don't Sass Me", An American Experience 2003, Associated Artists, Winston-Salem, NC, 2003 E. Hailey Most Expressive Award for, "Tribal Woman", Louisville Craftsmen's Guild, Patio Gallery, Louisville, KY

Gloria is also published in the following publications: We 'Moon 2005 Date Book, Mother Tongue, Ink., Estacada, OR., Magic Patch Magazine, Lyon, France, Issue #18, 2004., We 'Moon 2004 Datebook, Mother Tongue Ink., Estacada, OR., The Forest Echo, Bernheim Arboretum and Research Forest, Clermont, KY, Winter, 2001. The Courier-Journal, Business Section, Louisville, KY, Feb. 26, 2001.

Gloria's professional affiliations are: Louisville Area Fiber and Textile Artists (LAFTA), Louisville Artisans Guild (LAG), Juried Member (formerly Louisville Craftsmen's Guild), Louisville Visual Art Association (LVAA), Women in the Arts, Indianapolis, IN

Her website is http://home.insightbb.com/~gloriasgoddesses

Who's Who Kentucky artist Wilda Collins

Wilda Collins of Scottsville, KY is an artist and an award winning photographer who grew up on a farm in a very rural area of Western Kentucky where there were not a lot of chances to be exposed to the art world. Grade school was a one room school, where one teacher taught all 8 grades. High school was also small with only 12 students in her graduation class.

Upon graduation, she went to work for the telephone company, married and had a family. After spending 40 years with the telephone company she retired in 1990 and was introduced to oil painting when a friend paid for 2 Bob Ross classes as a retirement gift, taught by an instructor from Nashville. Next, was a community education class where she met someone who was taking classes from Evelyn Law in Scottsville KY.

Wilda Collins, Award Winning Photographer of the Scottsville Art Guild

In 1992 she started going to Evelyn's classes twice a month and continued 4 years till she gave up teaching because of her eyesight. Since then she rarely paints as other things became more important, like spending time with her two youngest grandchildren.

Wilda has been doing photography for about 30 years, but she has had no formal training. It is just a hobby for her personal enjoyment and pleasure. Of course it helps to have interesting subjects to photograph, such as her grandchildren.

Wilda started entering exhibitions at US Bank about 10 years ago as an amateur and have won ribbons there, and also at Scottsville and Tompkinsville. In February 2007 her work in photography was on display at the Scottsville library.

In 1990 Evelyn Law and 3 others formed the Scottsville Art Guild and Wilda joined in 1992, serving as President for 12 years from 1994 to 2006. The Art Guild has a show each August, and celebrated their 16th year in 2006. Their purpose is to promote art for the area with the show and arrange classes for adults and children to further promote their love of art.

Anyone interested in joining the Scottsville Art Guild may call Wilda at 270-843-2355 or email her at COLLSKY@aol.com.

Who's Who Kentucky artist Chad Logsdon

Chad Logsdon says he has been drawing since he was old enough to hold a pencil. Though he has no professional training he did take art classes in high school.

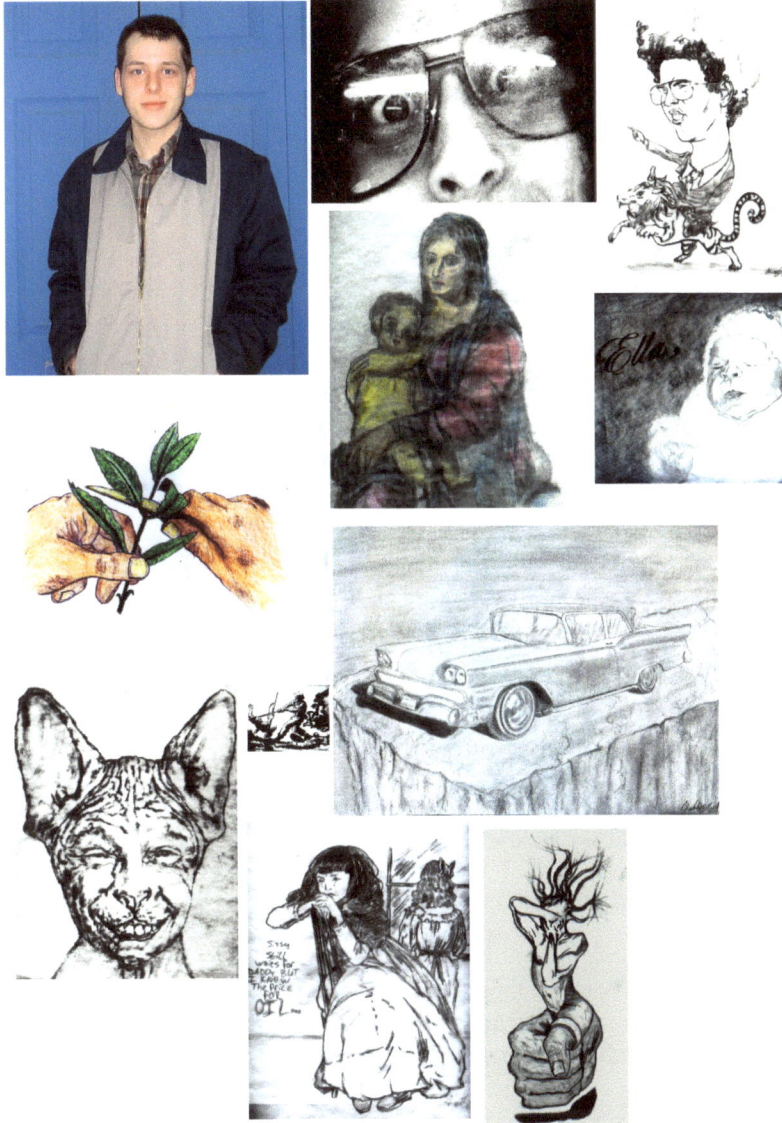

Chad living in Bonnieville enjoys the media of charcoal and graphite pencils. His format is sketching and professes not to enjoy painting at all even though he has done work in acrylics.

Since Chad sells most of his work he can be considered a professional artist and he specializes in original pop art, modern art, tattoo flash, custom "tobacco" pipe making, sculptures, wood carving, and wood burning and basically anything associated with or considered "art".

Chad does many art renditions from photographs and welcomes your inquiries for pictures of your loved ones on cards or invitations. He likes his sketches to contain something that makes the viewer respond differently each time they look at it. One of his goals is to be an influence on our community's young people.

Chad is currently in the National Guard and seems to be looking forward to being called to do what he can to ensure world peace and while here he can be reached at his studio office at 10930 No. Dixie Hwy in Bonnieville or you can write him at P.O. Box 568 Munfordville, KY 42765. His studio phone is 615 378 2252

Who's Who Kentucky artist Mark J. Klimczak

Many of us buy candles for our own use or for gifts, rarely ever thinking of anything about them except for the color and perhaps the fragrance they may emit. Candles come in all shapes, sizes, colors, scented and unscented. Today most of them are made by machines and there are still people who handcraft them as hobbies. Occasionally one comes across something really special in the craft marketplace and that is what I found when I met Mark Klimczak, a Kentucky candle maker with an environmental soul!

Mark is the creator and founder of Old Louisville Candlemaker and his slogan is "Illumination the Hearts of America, one candle at a time". His credo is working with the environment not against it! Mark is a native of Michigan who moved to Louisville in 1991.

Mark is a true artist in love with his craft whose candle making interest began as a child when his parents gave him a small candle making book, some string, crayons and several boxes of canning paraffin back in 1965.

Because Mark, as a child, had a limited income and was always running out of wax he started hounding family members and friends for their wax remnants. This became the beginning of a successful recycling program that has developed over the past 30 years which has led Mark into the experimentation process and technique of cleaning and purifying wax material thus rendering them into a useful and environmentally friendly material.

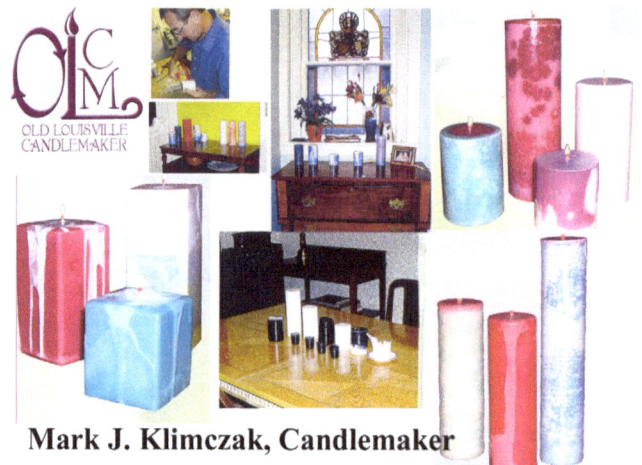

Mark J. Klimczak, Candlemaker

Finally in May 2005 one process yielded the result that hoped for, a wax that burns cleaner than the material it originated from. This new wax is called "Two Illume". Meaning twice lit twice burned and now all of Mark's unique freestanding candles are carefully hand-crafted from the recycled "Two Illume" wax thus giving them the artistic appearance and burning quality that sets them apart from other candles.

Mark creates all his candles at his studio in Historic Old Louisville at 1629 South Third Street #3. He works with local retailers who have become collection points for paraffin remnants including several churches and private organization who have in-house only collections. These are not open to the general public.

What this writer likes best about Mark's beautiful candles is that they are handcrafted in small batches using Mark's proprietary "TwoIllume" recycled wax which reduces the amount of solid waste sent to the landfills and secondly their candles are better for the air quality since their wax is made from wax remnants which burn cleaner than paraffin. In June, 2004, Mark's candles were juried by the Kentucky Arts Council's Craft Marketing Program which is a division of the Commerce Cabinet. All of his candles proudly bear the "Kentucky Crafted" symbol which represents and assures you of the highest quality, originality and design. Mark also offer's a very unique service which candle repair and refill for those of you who have special candles that mean a lot to you. Don't discard them; just call Mark at 502 637 8520. Also coming up in the future are a limited number of distributorships for local gift shops who want to stock these beautiful and very affordable candles.

For further information you can call Mark at the same number.

Who's Who Kentucky artist Kenneth Vetter

Kenneth Vetter does not consider himself an artist. He says "my brother is an artist, my two sons are artists, but I am not." Well, whether he considers himself an artist or not is beside the point. I consider him to be highly artistically creative!

73 year old Kenneth Vetter has been drawing, sketching, doodling, and creating since he was a small child. A native of KY growing up in Colesburg, he eventually moved to Indiana where he became a professional welder and boilermaker and that trade brought him to Spain on several occasions and other parts of the United States where he was the foreman of large projects. During that time, the artistic side of him created little art items out of metal and railroad spikes that depicted people doing various things and these became quite popular selling items for him. He also engaged in artistic iron projects of on larger scales and created a method for twisting iron pipe for fences and other projects.

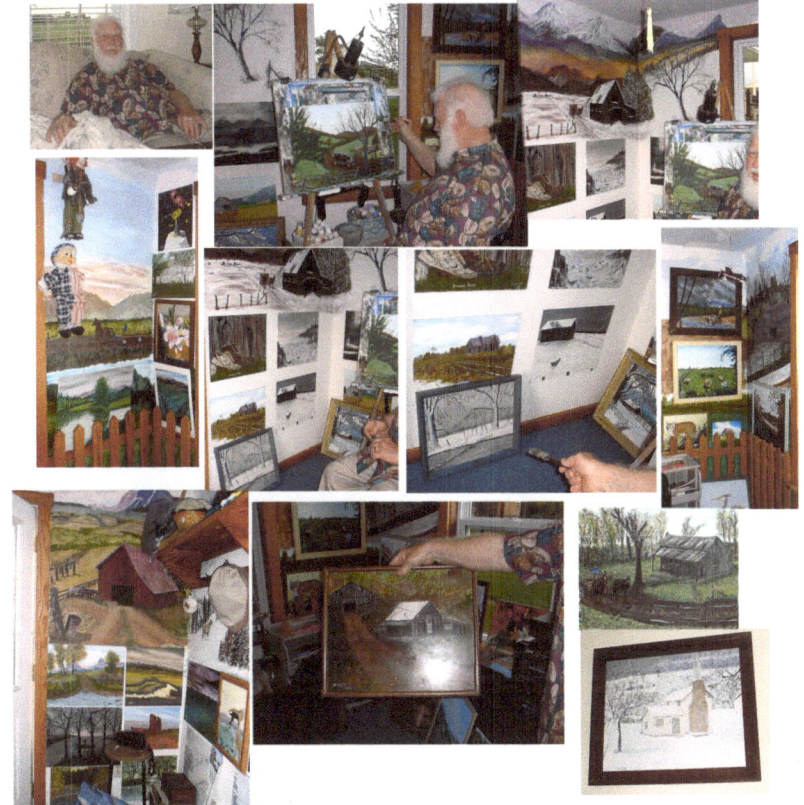

About 6 years ago his brother convinced him to paint in acrylics as a method to reduce stress and Ken has not stopped since then. Retiring 3 years ago from his own welding business in Indianapolis, he and his wife moved to Cub Run, bought a small home and completely restored it. He created an art studio for himself where he spends a good portion of his time painting. The walls of his studio are painted with murals from his memory and there he creates many of his canvases.

Ken has no formal training, but he finds he can create paintings from memories and small photos and even from a paused section of a video tape. His paintings are full of Americana. He still creates iron art from broken shovels and recycled metal tools for garden art and weather vanes.

At 73 there is no stopping this fellow. He is currently helping his son build a large pole barn and when not doing this and painting he helps his wife in the garden which is a pleasant chore for both of them. Their main crop is garlic and last year they grew garlic that weighed in at 1.4 pounds each!

You may make an appointment to see his works and to buy them and some of their garlic by calling him at 524 4303.

Who's Who Kentucky artist Rosie Hays

Off the beaten track, back in the wooded area of Bonnieville, lives Rosie Hays, potter, artist, organic gardener and a "mother earther" who truly believes in "Voluntary Simplicity". This multi-talented gal who is a native of Germany shares her life with her husband, Sam, who is a native of Eastern KY. Sam worked for our government in Germany for many years and she and Sam found their homestead property in 1994. Between that time and about 18 months ago when Sam retired and they were able to move back to the USA, they would vacation here off and on and started building their buildings.

Rosie is a potter and had a studio and school for teaching pottery in Germany and soon hopes to have something similar going her when she and Sam finish building her studio.

This writer, having traveled to many places in Germany and Austria, was delighted to meet these charming, hardworking people. She and Sam have built their home out of straw bales and it is a delightful, warm, charming European style home. They are currently building a larger building the same way.

Rosie has filled their home with her pots and dishes, plus the handmade tiles she has created for the back walls of her kitchen. She also has the walls decorated with many of her paintings which are painted on the back of glass.

Rosie's family was professional woodcarvers and furniture makers and her home reflects some of their work. She also has many "Shrunks" that she has hand decorated.

Rosie's talent lies in many directions and I was delighted to see the hand painted candles and eggs she has created.

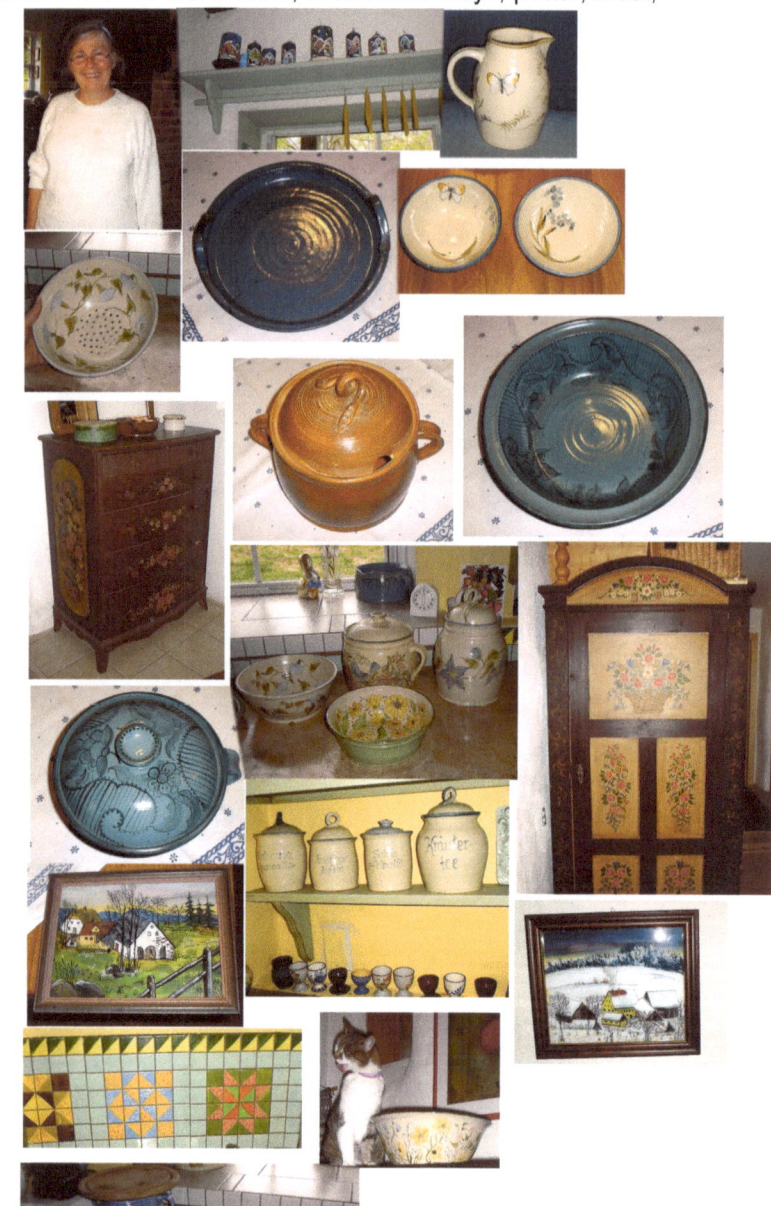

Rosie Hays and some of her art work and pottery

Rosie said because her family was involved in woodcarving and her father was a master wood carver that she decided to take up that art also. However, after the first time she cut herself she decided she would try another artistic medium and that turned out to be clay and the potter's wheel.

Completely self taught, Rosie loves the art of pottery and has been doing it for over 15 years. She says "clay has so many possibilities and clay is so forgiving. When one does not get it right, one can just mush it all together and start all over again." She often uses the under glaze method of painting her pottery and then firing it. Some times she uses the Majolica method of painting onto the glaze.

There is a lot of history to this method and merchants based on the island Majorca shipped so much of this pottery from Spain to Italy that it became forever associated with the island.

After the Moors were thrown out of Spain, majolica potters set up small factories in Italy near the mineral rich banks of the river Metauro in the towns of Deruta, Gubbio, and Faenza where the finest clay deposits and minerals for the glazes were to be found in abundance. In the 16th century luster glazes similar to those used in Valencia and Talavera, Spain were developed in Umbria as well as metallic gold and ruby red iridescent glazes.

Eventually Majolica crafters settled in many other parts of the world where the craft developed into new and distinctive styles. In Holland it became delicate blue and white Delftware, in Germany it became dainty Dresden porcelains. The French name reflected its Italian origin, *faience* after the city of Faenza, and in the New World it was called Talavera after the potters who immigrated to Puebla, Mexico from Talavera de la Reina, Spain between 1550 and 1570.

Majolica or *Maiolica* as it is known in Italian is the quintessential expression of the Renaissance potter's art. Everyday objects like plates, jars, and pitchers were hand painted with robust classical borders, portraits, historic scenes and geometric designs similar to those found in illumination and tapestries. The colors used for the decoration on a white base glaze made of tin or lead oxide were limited to deep blue, brownish purple, copper green, warm yellow, and rusty orange yet they were used in bold combinations to evoke a much wider range of tones and hues.

By the end of the 16th century black, scarlet red, bright purple, and grass green were available as well. Though painted pottery was made in many lands, Spanish Majolica was well known for its final lustrous coat of iridescent clear glaze.

This took a secret process and required great skill to produce. Until the 16th century, Italians could not achieve the same lustrous finish so their painters concentrated on the beauty of the painting and clarity of the colors. Thus Italian Majolica came to be highly prized and imitated throughout the world.

Wealthy patrons began to demand even more elaborate and artfully painted platters for display. These elaborate pieces were called *Piatto de Pompa*. Majolica with scenes from history, the Bible or Classical literature were called *Istoriato* and often included heraldic display of flags, armorial crests, and mottos.

Thus Rosie's pieces are the result of all this history and her pieces are historically correct and quite beautiful and each one a truly functional work of art that can be used daily in one's life, from pitchers to colanders to canisters to dishes and bowls.

In Rosie's busy artistic life she and Sam manage to work on building their other straw bale building, take care of goats, chickens, ducks and maintain two large organic gardens and live in harmony with their surroundings and contribute a lot to putting back as much as they take out of this planet.

Who's Who Kentucky artist Bev McManimie

Just when you think there is no longer any use for it or life in it, along comes Bev McManimie of Cave City, KY with her Tole paints, brushes and incredible talent and that old coffee pot, milk can, school desk or bar stool become beautiful works of art.

Bev, a native of Bowling Green, KY, lived in Montana, Wyoming and Idaho learned the folk art of Tole painting 15 years ago while living in Idaho. She says there are a lot of Tole painters in Idaho.

Bev loves to paint on yard sale items and has done tables, chairs, chests, a laundry hamper her dad made for her and she says basically she can paint on anything including candles!

The practice of Tole painting began in 18th century New England, and was also extensively carried on among German immigrants in Pennsylvania. We know a similar tradition occurs among Scandinavian countries and immigrants, including Norwegians, Danes and Swedes. German tole painting usually concentrates more on metal and tin objects, while Scandinavian may concentrate more on wooden objects and furniture. Patterns in the two traditions vary slightly as well. Modern tole painting typically uses inexpensive, long-lasting and sturdy acrylic paints. Good quality wooden work is sealed, primed and sanded before the decorative paint is applied. Metal objects, especially tinwork, should be quality galvanized tinplate, not terneplate (lead solder plated), and should be primed with rust-fighting metal primer, and then painted with a background-color coat to prevent rust. Bev includes all these techinques in her elegant designs and expressions. Bev has been doing shows all over the United States including Yellowstone National Park, Montana, Wyoming, Idaho, Oregon, California, TN, KY, FL and Alabama. In 2005 she did 22 shows and that made her decide to rethink her marketing stratigies. You will soon find many of her beautiful items on her own website as soon as it is completed.

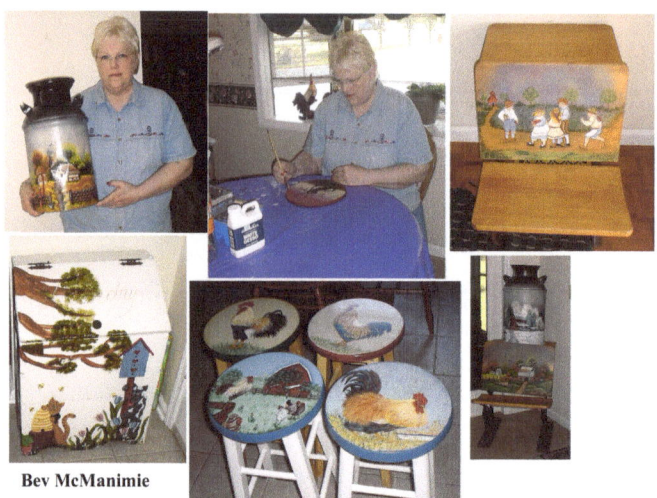

Bev McManimie

Unlike many beginners who purchase patterns from craft stores and paint on inexpensive imported wooden "craft objects", Bev's work is totally unique as most of her designs are her own. The most beloved family objects tend to be high quality utensils or furniture, painted freehand with favorite patterns, colors or flowers, humorous themes, family in-jokes, or illustrations of favorite or family stories. The perceived value of a tolled utensil increases with its quality as a utensil, the quality of the art, and the personalization, the story, of the work such as the bar stools she created for her sister with paintings of plates full of strawberries or blueberries and waffles complete with knifes and folks. Bev is fortunate to have a husband, Jan who is the other half of their booming business which is called, " A Brush of Country Crafts". Besides all this painting, Bev is the Human Resource Manager at Dart and enjoys her job there since she and Jan moved to KY about 2 years ago. Jan on the other hand provides Bev with a lot of the stock she paints on and we will discuss his input and talent in another article since he is a gifted crafter also who has brought his end of the crafting part of their business into the computer age. Bev's favorite painting subjects are Santas and even though she does not really care for the color orange she will do seasonal things for Halloween. She also does Easter, Fall, Thanksgiving designs and paintings and will paint just about anything you want on anything you have. Bev is a member of the South Central KY Arts & Crafts Guild. For special orders you can reach her at 270 678 6532.

Who's Who Kentucky artist Jan McManimie

When one is into the arts and crafts it really pays to have an accommodating spouse and one such spouse is Jan McManimie. Jan, a native of Oregon, currently living with his artistic wife Bev McManimie in Cave City is the other half of "A Brush of County Crafts".

Jan retired from owning his own auto parts business after 35 years and now spends most of his time creating great items for their craft business. Originally Jan cut out the seasonal ornaments with a scroll saw and Bev painted them. However, since Jan is a "now kind of guy" he was impressed with Laser cutters. Laser cutting is a technology that uses a laser to cut materials, and is usually used in industrial manufacturing. However, Jan could see how their business could benefit by using this method of cutting since laser cutting works by directing the output high power laser, by computer, at the material to be cut. The material then either melts, burns or vaporizes away leaving an edge with a high quality surface finish which now gives the products they sell a more professional looking finish.

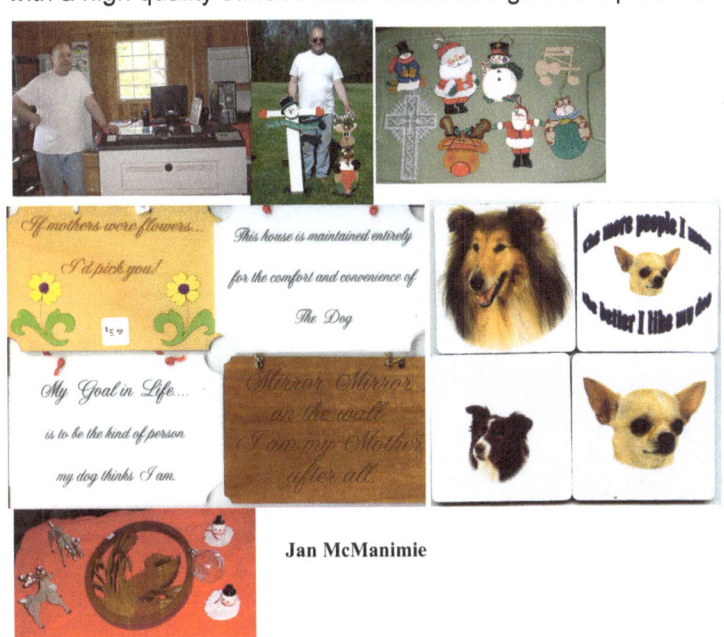

Jan McManimie

Advantages of laser cutting over mechanical cutting vary according to the situation, but important factors are: lack of physical contact (since there is no cutting edge which can become contaminated by the material or contaminate the material), and to some extent precision (since there is no wear on the laser). There is also a reduced chance of warping the material that is being cut as laser systems have a small heat affected zone. Some materials are also very difficult or impossible to cut by more traditional means. Disadvantages of laser cutting may include the high energy required. This disadvantage is offset by the high quality of finished product that is produced for the craft business and it gives Bev a beautiful end product to paint on. Plus it then allowed Jan to discover greater ways to expand their craft business and he now does presicion engraving on glass, plastic, metal, wood , tiles, you name it!

Along the way Jan discovered the art of sublimation and he can now put Bev's paintings on cups, glass cutting boards, coasters, T-shirts, tote bags, aprons, mouse pads and anything else he can think of.

As if all this isn't enough for Jan to do he also utilizes his large heat press machine to put designs on tote bags, t-shirts and other cloth items. Jan says some of their biggest customers are dog owners since he creates all kind of images of people's dogs and even cats with any and all of his specialized equipment. All this modern equipment Jan uses does not take the "craft" out of arts and crafts. It just gives their products a finished basis upon which to do the final hand crafted touches. Jan is also a member of South Central KY Arts and Crafts Guild.

For more info you can contact Jan at 270 678 6532.

Who's Who Kentucky artist Daniel Hawkins

The 6th, 7th and 8th grade kids love Bonnieville math teacher Daniel Hawkins and he loves teaching math to the kids. It takes up his workday. However, when he comes home and wants to relax he heads out to his workshop and his favorite hobby which happens to be woodworking!

Daniel is a native of Munfordville and has worked in woodcrafts for about 6 years. He does delicate woodworking such as the baby crib he made for his wife when they were expecting their first child or the beautiful pine pie safe for their dining room.

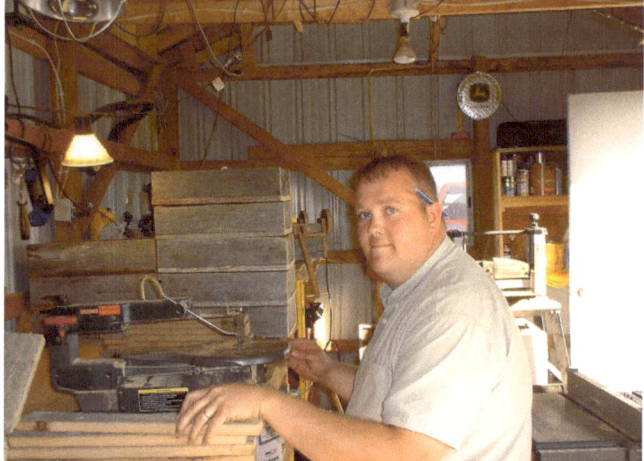

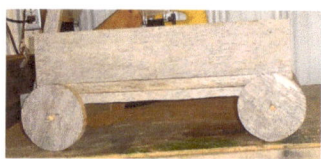

Four years ago he decided to recycle barn boards and find a creative and attractive use for them.

He found he could salvage the wood and use it to make benches, picture frames

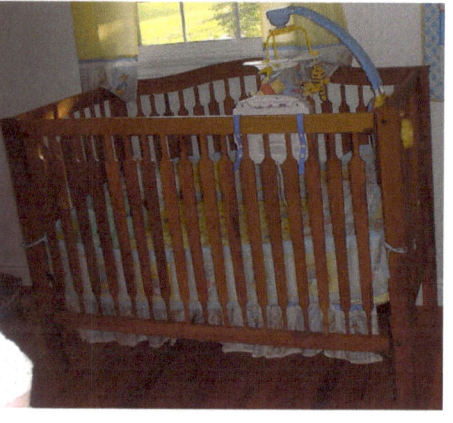

and planters such as wagon planters and water can planters. When I went to interview Daniel it was just before Mother's Day and he was busy filling orders for wagon planters.

Daniel will take orders and you can get the planters unfilled starting at the low price of $20.00 or filled with flowers starting at $30.00. Local artists can get really reasonable handmade barn board frames for their art work by calling him at 270 524 4819. He will also take orders on his benches.

Daniel says he likes to work with pine and oak best, but finds it fulfilling to be scouting out the countryside for old barn wood and removing the wood, after getting the owner's permission, and then making the old wood into some useful again.

During the summer months when the Munfordville Farmer's Market is open on Tuesday and Friday mornings you can usually find Daniel's mom at her stall selling some of his planters.

Who's Who Kentucky artist Howard Margolis

World traveler, Howard Margolis of Munfordville and Bowling Green, KY, considers himself a native of the United States since he has lived all over the place, including Puerto Rico and Italy after he was born in Binghamton, N.Y. This writer will agree with his assessment of himself on this matter. Well educated, bright, charming, with a grand sense of humor especially when he aims it back at himself, as one can see in his self portrait picture, Howard was a delight to interview.

Basically with a degree in engineering, Howard spent many years working as an engineer in the industrial construction field. Part of his work was as a documentary intermediary where he would just go out with a camera and point and shoot at beams, walls, foundations documenting the daily work.

About 25 years ago he discovered other aspects of photography in a non-formal educational way. He liked taking pictures of other things, their shapes and forms, the sand, water, seashells, and he shied away from taking pictures of people as he never wanted to intrude upon them.

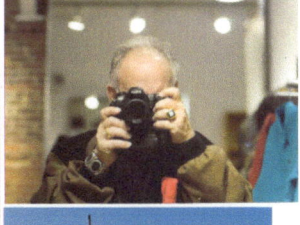

In 1979 Howard built his first computer and then in the mid 80's he discovered that computers were being built with the capabilities of getting into graphics. Along the way he was learning about timing, composition, exposure and depth of field.

Howard Margolis
Photographer/Artist

About 2001-2002 Howard got his first digital camera and another whole world opened up for him. He could take a photo and immediately look at it and he could manipulate it right then and there. He was no longer at the mercy of developers which gave him no control over the developing side of photography. He discovered he could add software such as Adobe Photo shop and Corel Painter and like most people who are really into this type of art work he upgrades as newer and better software comes along.

Howard uses a Nikon D-200 which is a semi-professional camera and he has all kinds of lenses and filters for it.

Having retired 2 or 3 times all ready from "putting beans on the table" jobs, Howard works 3 days a week at the Shutterbug in Bowling Green and he and his wife Pat, who works in Munfordville at the County Extension office, support a lot of Hart County issues such as tourism, the Munfordville Welcome Center and the Hart County Historical Society just to name a few.

He feels that photographic art is his "new" kind of work and since he has discovered digital painting he is having lots of fun as one can see in his yacht painting which he has done with Corel Paint. This was originally a photo he had taken and he can now turn such photos into art on paper or canvas. He says it is amazing how he can control the strokes, the colors, the textures and put it any kind of paper or even canvas.

Howard's goal is to do better photography and that is as simple as that. Howard belongs to the photography club in Bowling Green, KY.

Who's Who Kentucky artist Becky and Jackie Gray

Jackie Gray says his name really should be Manual because he does all the manual labor. He plants ¾'s of an acres with 800 to 900 gourd plants each seasons, cares for them, harvests them, dries them and even does the basket weaving on those that require that finishing touch.

Becky Gray helps with the drying, but mainly does all the beautiful hand painting on each and every gourd.

Together, this husband and wife team, do about 20 to 25 shows a year selling their artfully decorated gourds. Becky says she started painting on wood and anything else she could find. Then about 10 years ago she discovered the art of gourd painting and has not stopped since then.

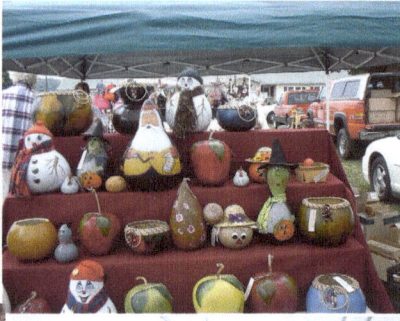

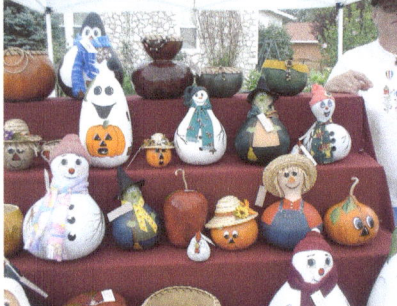

Becky Gray and her hand Painted Gourds.

She also creates about 30 different Christmas ornaments from small gourds and she makes delightfully fresh looking strawberries from nest egg gourds.

They said that once the gourds have grown they usually leave them in the field until they are partially dry before they harvest them.

The Grays are members of the KY Gourd Society, Inc. an IOTA chapter of the American Gourd Society.

Earlier this year they opened up a new store called "Front Porch Crafts" at 403 Robin Rd. in Horse Cave, KY.

They are open from 8 am to 4 pm. However, you may want to call 270 786 2782 to make sure they are there the day you want to visit.

They offer a variety of hand crafted items such as hand painted Gourd crafts, woven gourd baskets, raw gourds are also for sale, Christmas ornaments and Chair caning.

You can also find handmade soap by Linda Harlow of Glasgow and handmade scrubbies by Linda Richardson.

Who's Who Kentucky artists Debbie Puckett and Lanni Schroeder

You can be "so-so" friends or "Sew-Sew" friends as Lanni Schroeder and Debbie Puckett have been for the past 9 years creating and sewing their way through a hobby that earns them recognition and money.

Sewing is really an art unto itself. Years ago it was something one did because there was not much spendable income around and most moms made their children's clothes and usually their own and their spouses. Today not many people really know how to sew and that thankfully is starting to change.

Lanni Schroeder, a native of Michigan, lives in Cave City, KY and Debbie Puckett, a native of Horse Cave, KY have a business they run together called, "Back Porch Designs".

Besides the sewing these two artists paint and decorate bird houses, towel racks, welcome signs and many other things. They also create dolls.

Lanni says she loves making the dolls, purses and especially the potato pouches. This is one of their best sellers. A pouch that you place 4 potatoes into, pop into your microwave and presto 8 to 10 minutes later you have 4 perfectly baked potatoes!

Debbie says her favorite thing to create is the fringed throws they sell. Their most popular one is the John Deere Fabric design.

When these two sewing artists are not out doing craft shows you can reach them at 270 786 4022 to make an appointment to buy any of their wonderful locally made products.

Lanni Schroder & Debbi Puckett are "Sew Sew" Friends!

Who's Who Kentucky artist Patricia Ritter

When does a hobby become a passion become a business? When your name is Patricia Ritter and you decide after 20 years working as a social worker and 5 years as a bridge toll booth collector that you really, really want to wake up each morning and look forward to whatever it is you do to put "Beans on the Table!"

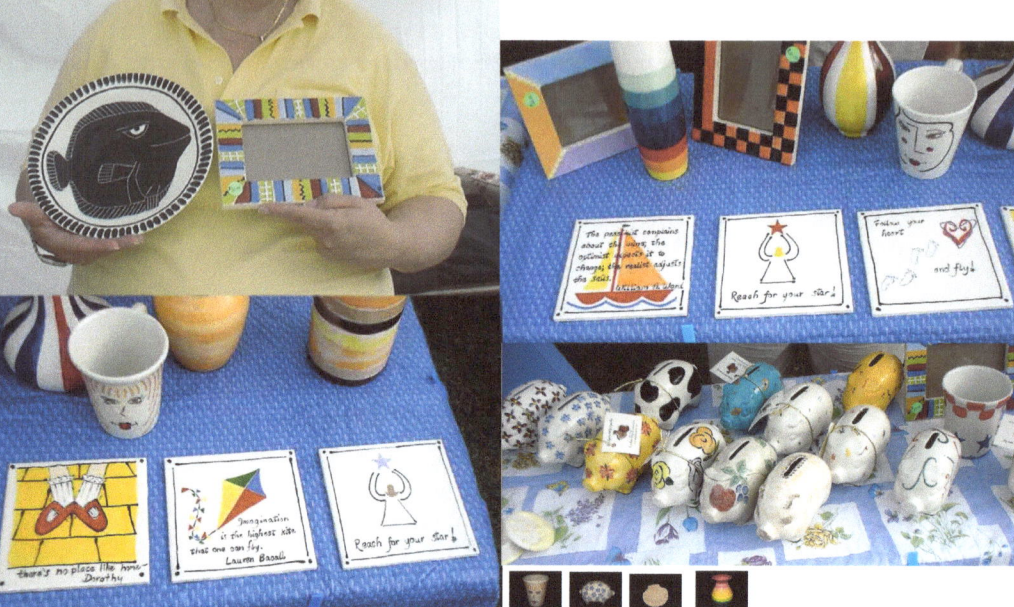

Patricia Ritter is a native of New Jersey who lived in Florida and decided to check out life in KY. After visiting Edmonton, she decided this was the place for her to open up her business Cedar Hill Ceramics.

As an artist and proprietor of Cedar Hill Ceramics she has created a studio and an internet studio of hand painted functional ceramics. You can view and order all her original small works of art at http://www.cedarhillceramics.com

She started this business as a hobby in 1998 in Florida and she felt the need to expand it into something that was gratifying, satisfying and joyful. Her signature pigs are one such product.

She will do commission tiles for you should you have something special you want painted on a tile. She can be reached at 270-432-5929

Pat says, "The idea for my website was conceived in 1998, when I began the hobby of painting functional ceramics. I found a studio where I could go and spend hours and hours painting and not feel tired at the end of the day. I enjoyed painting so much that I needed to develop a way to do it more often and more economically. Hence, setting up my own studio seemed a good idea, and I have finally made my dream come true. Each of my ceramic pieces is hand-painted and unique.

The over glaze used on each piece is non-toxic and food-safe. While in theory the pieces should survive the microwave and dishwasher, I myself, opt to be safe, and hand wash all of them. Feel free to browse. My hope is that you find a piece you will enjoy having as much as I enjoyed making it for you."

Who's Who Kentucky artist Joe Larson

Munfordville, KY has some really talented people and one of the most talented I know is Joe Larson who lives and works with his wife Kathy Zajac. Joe, a native of New Jersey, lived in CA for 5 years after leaving the air force in 1968. He and Kathy wanted to find a little piece of the universe where they could be alone with nature and live a quiet life and they found such a place in Munfordville in 1975.

They started to build their home and all they wanted was to put in a few stained glass windows, so they made them. Neighbors who saw their windows were soon asking for their own custom made windows and in 1981 Home Studio was born. Since then they have gone on to making windows for churches, homes and businesses all across the country.

Though this article is basically about Joe as I did one on Kathy in 2006, it is almost impossible to discuss Joe without including Kathy. They are basically two halves that create a whole!

He and Kathy do a lot of art shows exhibiting their one of a kind art work, especially in fused and slumped glass which they have exhibited at the St. James Art Show, Ursuline Campus Art Fair in Louisville, KY, Keeneland Christmas Show in Lexington, KY, Penrod art show in *Indianapolis, IN and craft shows in Nashville, TN and Ft. Myers Fl.

Joe and Kathy constantly attend workshops to keep abreast of current trends and to learn new creative techniques. Joe likes drawing his own patterns and he says, "There is nothing like seeing the final product from your own design." Joe even does glass painting with an airbrush. He says his most favorite thing in doing his art is the "Spec" work he does that is sold at the art shows.

The name of their studio is Home Studio Art Class and they have a web site http://www.homestudioartglass.com/index.html where you can see a lot of their work in beveled glass, fused glass, slumped glass and many "one of a kind" original and functional works of art.

Joe is also a very talented musician and he teaches banjo at two area music stores, KY Music in Bowling Green, KY and Heartland in Elizabethtown, and he also has a few banjo and guitar students in Munfordville. His band is called "Down on 5th" and he has a website. http://www.downon5th.com and you can hire his band for your weddings, birthdays etc or you can contact Joe at 524 0757 should you decide to have your child or even yourself take banjo lessons.

Who's Who Kentucky artist Liz Davis

Folk artists like Liz Davis are a rare breed in the business of doll making. Liz is a native of Grace County, KY and lives in Dundee, KY. She has been making dolls for 30 years and when her husband was alive; she was a homemaker, mother of 3 children and created about 50 dolls a week! She says she has lost count of all the dolls she has ever made. When she became a widow about 10 years ago, she realized she had to get an outside job, so she had to cut back on her doll making.

Though she has cut back on the amount of dolls she makes each week, Liz Davis is still active in the doll making world. Her Bluegrass doll is the official Bluegrass doll of Ohio County. It was selected as one of Kentucky's best kept secrets on QVC.

She was commissioned by former First Lady Judi Patton to create the Blue Ribbon Doll used in Patton's fight against child abuse. Liz was selected as one of the best women artist in the past 30 years. She is a juried member of the Kentucky Craft Marketing Program. Her dolls have been chosen for the Kentucky Collection, an exclusive line of high-quality products that reflect the unique flavor, culture and traditions of the commonwealth.

Liz Davis and her dolls

Liz Davis' dolls have been in Berea, across Kentucky and New York recently. Furthermore, Liz's "Frizzy Lizzy Doll" is in the December issue of a New York Art Magazine, -Niche. Sloan and twenty other Kentucky art pieces are being displayed in a two piece ad for the big celebration -- Kentucky Crafted: The Market-2007, twenty five years of quality and style. The Market is a state sponsored wholesale and retail show in Louisville.

"Fiddling Fifi" the Bluegrass Lady and the Fiddling around in Kentucky pin, are among 100 greatest gifts from Kentucky in the December Issue of the Kentucky Monthly magazine. The magazine from Frankfort is a general interest magazine about Kentucky and Kentuckians. Reflecting Kentucky as it is today while not forgetting the people and events that shaped Kentucky. Liz was invited by the Berea Arts Council to exhibit her doll Memories 1967-2006. In a invitation only exhibit -The Art of the Doll at the ArtSpace Gallery in Berea.

Liz's new doll the "Ohio County Guardian angel" is available at Barnes Antiques and Pedal Pushers. Of "Fiddling Fifi the Bluegrass Lady Musical", Liz says, "Ohio County is the Birth and burial place of Bill Monroe and my doll is the official Bluegrass doll commissioned by Judge Executive, Dudley Cooper. She was chosen as one of the Best Handmade products in Ky. by QVC and she sold out in 3 minutes!

"American Patriot" is a child size doll chosen for Morehead art gallery's 911 artist booklet and traveled around to different galleries for 2 years. Phyllis George selected the work. "Tom the Dundee Goat" was inspired by the Goat weather vane in Dundee Kentucky. Liz had a toy box of her dolls at Louisville markets Designers showcase.

Liz will create your doll on commission basis and the prices start at $45.00 and run to about $100.00 unless you want something really unusual. All her dolls are named, signed, dated and most are numbered. You may reach her by phone at 270 276 5018 or write her at 11308 State Route 69 North, Hartford, KY 42347. Her email is lizd@owensboro.net

Who's Who Kentucky artist John Haywood

Born in a holler in Eastern Kentucky in one of the poorest counties in the country, John Wezley Haywood saw life differently than children who grew up in more economically developed areas. He lived in an isolated community called Risner that was named for his Mother's family. During this time both Haywood and his community was being changed by outside influences which came into the area by means of mass communication and corporate development. For a kid, these influences were from an Emerald City where hopes and dreams could come true.

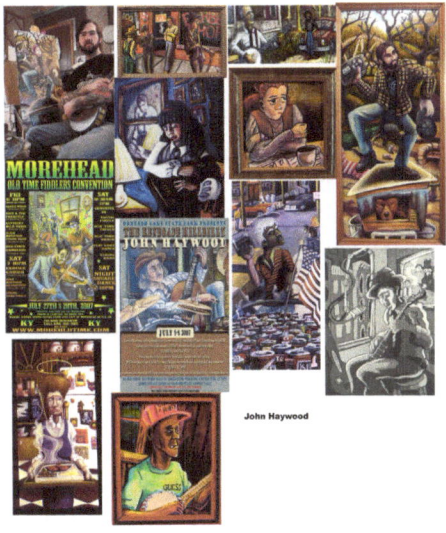

John has always been an artist, drawing as a child and it used to get him into trouble in school. By the time he had finished high school he had no plans. When his girlfriend, now wife, convinced him that he could really find a way to turn his talent into something positive, he began to take art classes from Thomas J. Whitaker, the "Greatest Appalachian Artist." It was also at this time the he began exhibiting and selling his paintings. He decided to pursue a career in graphic design at Morehead State University where upon graduation; he felt he would rather paint than design. When his wife took a job teaching near Louisville, he jumped on the chance to further his career in the big city where he received a master's degree from the University of Louisville. His strong brushwork and frugal choice of elements in the painting's composition show the idea that childhood is more than a carefree commercial for lemonade. John says, "Chasing these dreams brought me to Louisville where the culture shock instilled in me a new appreciation for my Appalachian heritage." Many of the traditions that had been handed down in the Eastern Kentucky region are now forgotten, but come alive in John's work.

John paints the real Kentucky. His artwork wallows in the stereotypes and pays tribute to lifestyles that make Kentucky and Appalachia one of the most unique and celebrated places in the entire world. The paintings tell stories of hell raising hillbillies, hardened mine workers, mountain musicians, and more. Established galleries such as the Cinderblock and Swanson Reed Contemporary in Louisville, Kentucky have carried his artwork. He has also sold work through the Kentucky Museum of Art and Craft, and has recently been asked to sell work through the Kentucky Artisan Center in Berea. In June 2006 he received a professional development grant from the Kentucky Arts Council for a solo exhibition in Ashland, Kentucky. John is also a juried member of the Kentucky Arts Council's Visual Art at the Market program. John Haywood can also be found participating in various arts and music festivals across the region.

His work has been collected by a variety of folks in an out of state. Environmental biologists, college professors, famous banjo players, disc jockeys, and tattoo artists are all proud owners of Haywood's paintings. As the list grows so does the demand for his artwork. John says, "I think that with the way things are today, people are looking for work that will connect them to something or someplace and as our culture becomes more and more homogenized, we are losing many of the characteristics that make us unique," Haywood currently resides in Louisville with his wife, the writer Kelli Brooke Haywood, and his daughter Deladis Rose Haywood. He is also a tattoo artist and old time banjo player. He has designed the album jackets for any music he is part of. John says, "All artists should be inspired by what is around them and where they come from."

You can find his art at http://www.haywoodart.com or you can make a special appointment to visit him at his studio by calling 502 899 1753.

His Exhibitions include 2006: SOLO EXHIBITION: THE RENEGADE HILLBILLY AT THE APPALACHIAN ARTISAN CENTER. Hindman, Kentucky. Organized by Deborah Mullins. , SOLO EXHIBITION: THE RENEGADE HILLBILLY IN ASHLAND, KENTUCKY. Anne Davis Gallery, Ashland, Kentucky. Funded in Part by a grant from the Kentucky Arts Council. , BIG BONE HOLIDAY $40 ART SHOW. Nancy's Bagel Grounds. Louisville, Kentucky. Organized by Brian Renfro. , FORECASTLE FESTIVAL. Art, Music, and Activism Festival. Mellwood Art and Entertainment Center. Organized by JK McKnight ,ARTISTS IN OUR MIDST. Group Show. Kaviar Forge Gallery. LOUISVILLE, KENTUCKY. , SEEDTIME ON THE CUMBERLAND FESTIVAL. Festival of Appalachian Art, Craft, Culture, and Music. Appalshop. Whitesburg, Kentucky. ,KENTUCKY CRAFTED: VISUAL ARTS AT THE MARKET. Kentucky Fair and Exposition Center, Louisville, Kentucky. A TASTE OF KENTUCKY CRAFTED. GROUP SHOW. The Kentucky Center for the Arts, Louisville, Kentucky.

2005 $20 ART SHOW, Cinderblock Gallery, 931 East Main Street, Louisville, Kentucky. Organized by Scott Scarboro. ,ROCK ART. Artwork by local Musicians. Cinderblock Gallery, 931 East Main Street, Louisville, Kentucky. Organized by Scott Scarboro. ,Kentucky Crafted: Visual Arts at the Market. Kentucky Fair and Expo Center, Louisville, Kentucky. ,Untitled Solo Exhibition, the Bike Depot Gallery, Louisville, Kentucky. ,BRICK HOUSE BENEFIT Bike Art Show, The Bike Depot Gallery, Louisville, Kentucky.

2004 UNTITLED, Two Person Exhibition. Appalshop Gallery, 91 Madison Avenue, Whitesburg Kentucky. ,$20 ART SHOW. Group invitational. Cinderblock Gallery, 931 East Main Street, Louisville, Kentucky. ,SOUTHEASTERN JURIED BIENNIAL. Group Show. Mobile Museum of Art, 4850 Museum Drive, Mobile, Alabama. Juried by Sean Ulmer.

ALUMNI EXHIBITION. Group Show. Claypool-Young Art Gallery, Morehead State University, Morehead, Kentucky. , 11TH ANNUAL JURIED EXHIBIT. Group Show. The Krempp Gallery-Jasper Arts Center, 951 College Ave., Jasper, Indiana. Juried by Thomas Pfannerstill. , WALL TO WALL (works on paper). Group Show. Jaffe Arts Center, 737-B Granby Street, Norfolk, Virginia. Juried by Nora Levine, Ces Ochoa, and Darlene Stoll. ,STUDIO ARTISTS' SHOW. Group Show. Cinderblock Gallery, 931 East Main Street, Louisville, Kentucky. ,BLUEGRASS BIENNIAL. Group Show. Claypool-Young Art Gallery, Morehead State University, Morehead Kentucky. Juried by John Begley. ,FOR THE LOVE OF PRINTS. Group Show. Genesis Art Studio, 1734 Bonnycastle Ave., Louisville, Kentucky. ,ROCK ART. Artwork by local Musicians. Cinderblock Gallery, 931 East Main Street, Louisville, Kentucky. Organized by Scott Scarboro. ,AIN'T GONNA GIT MY HOLLER. Solo Exhibition. Cinderblock Gallery, 931 East Main Street, Louisville, Kentucky. , THE WOMENS CLUB OF LOUISVILLE 66TH ANNUAL NO-JURY ART SHOW. YELLOW RIBBON. 1320 South Fourth Street, Louisville, Kentucky. Awards Judged by Jennifer Cheryl Deamer.

2003 THE SAINTS? Master Thesis Exhibition. Hite Art Institute, University of Louisville. Louisville, Kentucky. 2ND ANNUAL KENTUCKY ART CAR WEEKEND. Bicycle Artist. Kentucky Museum of Arts and Design. 715 West Main Street, Louisville, Kentucky. ARTS ON MAIN. 801 West Main Street, Shelbyville, Kentucky, Juried by Cal Kowal. ROCK ART. Artwork by local Musicians. Cinderblock Gallery, 931 East Main Street, Louisville, Kentucky. Organized by Scott Scarboro.

2002 THE SHED SHOW. various artists doing art installations in donated sheds and garages, Louisville, Kentucky. Organized by the Radix Commission. STEAL THE SHOW. 105 West Oak St. Louisville, Kentucky. Organized by the Radix Commission. ARTS ON MAIN. 801 West Main Street, Shelbyville, Kentucky, Juried by Cal Kowal. TRAVELING EXHIBITION, 600 Block East Market St. Louisville, Kentucky. Curated by the Radix Commission.

2001 ATE-UP, Homage to Automobile Culture, Semantics Gallery, Cincinnati, Ohio. Invitational. Curated by Jason Tingler. IN.FEST.ED, Independent Festival of Education, Bardstown Road Youth Culture Center, Louisville, Kentucky.

2000 Group Exhibition, Montgomery County Arts Council, Mt. Sterling, Kentucky. Juried by Joy Gritton and Steven Black Bear LaBoueff. Exhibition in conjunction with PICASSO AT THE LAPIN AGILE', Kibbey Theatre, Morehead, Kentucky.

1999 Group Exhibition, Adron Doran University Center, Morehead State University, Morehead, Kentucky. VISUAL ARTS GUILD EXHIBIT, Stryder Gallery, Morehead State University. Morehead, Kentucky.

1998 INTAGLO HALO, Two-Person Exhibition, Prestonsburg Community College Art Gallery, Prestonsburg, Kentucky.

Who's Who Kentucky artist Cynthia Carr

Working in clay is the ultimate art creation form as far as this writer is concerned. One takes a lump of wet mass and turns it into something functional and that is exactly what Cynthia Carr loves to do.

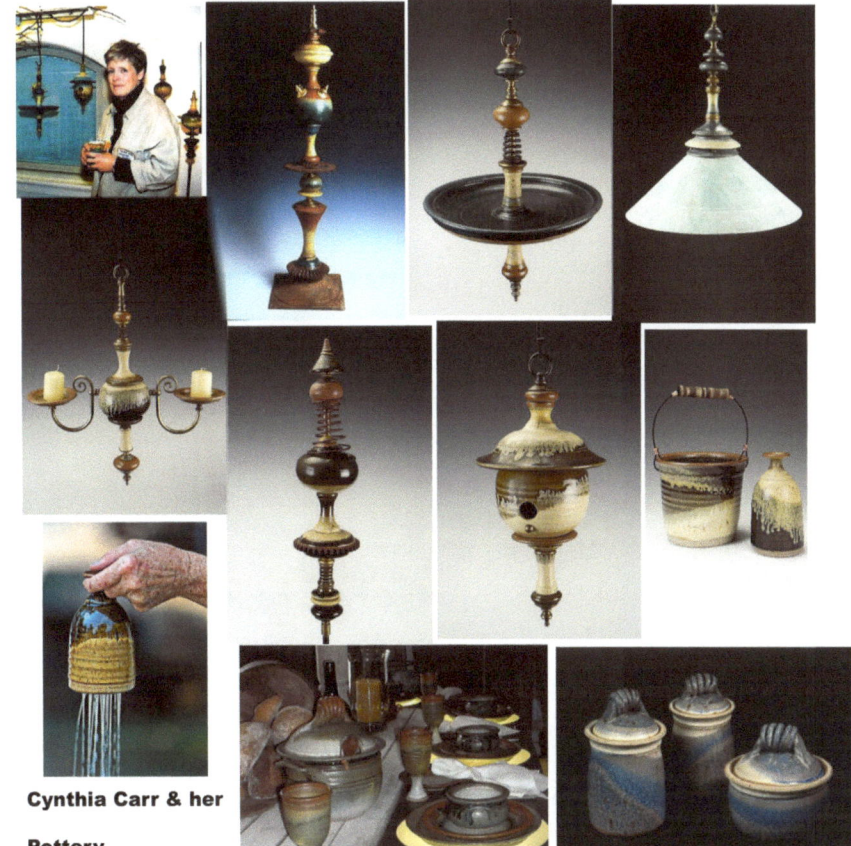

Cynthia Carr & her Pottery.

A native of Vermont, Cynthia was raised in Cleveland and received her BFA at the Cleveland Institute of Art. She then moved to New Orleans and received her MFA at Tulane University. She lived in that area for 8 years prior to moving to KY where she settled in central Kentucky in 1988. After purchasing a small farm on a scenic hilltop, she set up a pottery studio and did fairs as a part time project.

Cynthia says, "The rural and simplified lifestyle is reflected in my work. I mix my own clay and glazes that are fired in a propane kiln that I built. The part-time venture became a full time livelihood in 1991. Functional high fire stoneware with reduction glazes is produced and sold through the studio, juried art fairs, retail outlets, and galleries"

Cynthia does limited commissioned work, mentoring, panelist (Peer Review), festivals/trade shows and as soon has she has built her permanent showroom in her barn she will give private lessons.

Her functional pottery starts at $12.00 and runs to $80.00. Her new garden line runs from $75.00 to $1,200.00 and she says this line is a really fun thing to be doing. Cynthia is a collector of "found" metal objects that she works into the clay and has a great time creating garden totems, garden charms, garden birdbaths and other things. One the unique pieces she has is an item called "The Rain Maker" which waters plants.

Her phone number is 859 366-4439 and one may call her at that number to set up an appointment to visit her studio at 340 Henry Robinson Road.
Harrodsburg, KY 40330.
Her website is http://www.southernartistry.org/Cynthia_Carr

Who's Who Kentucky artist Lisa Austin

After having to give up many years as a professional potter Lisa Austin decided to become a Mixed Media Artist. She says, "I owned One Sky Pottery before having to leave clay due to arthritis and enjoyed working with fiber. However I had a hard time in the 2 dimensional aspect of that art form until I took a small workshop that opened my eyes, mind and heart to the 3 dimensional treatment of my current art form." Thus Lisa became a mixed media artist in 2002 and her work has been featured nationally and internationally. A native of Louisville, KY, she lives right in the area she was born into. Her wit and sense of humor comes through all her work, especially in a piece called "Carmemoranderized" and another one called "Hootchie Cootchie Mama".

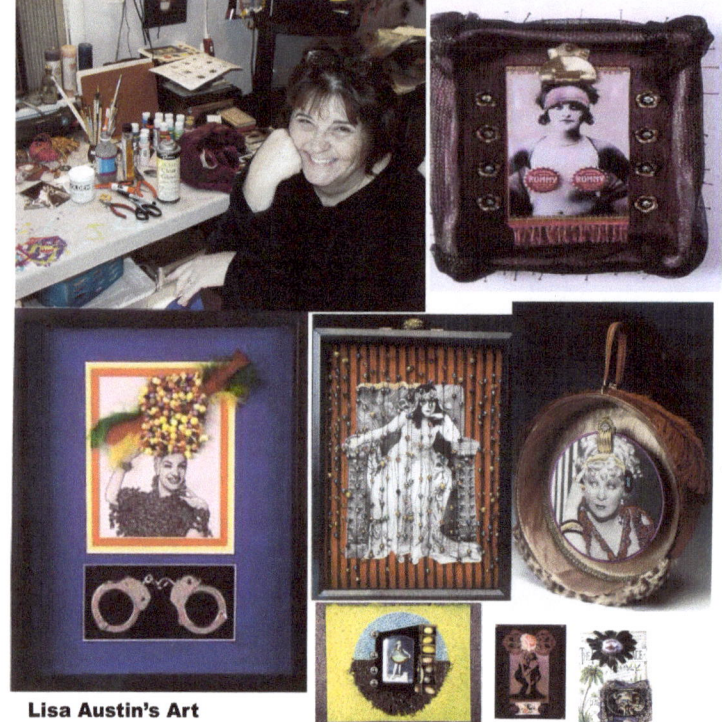
Lisa Austin's Art

She received her B.A. English. 1969 and her M.A. Humanities in 1975, both from the University of Louisville

This multi-faceted gal was a full time studio potter from 1982 until 2001 and as the owner of One Sky Pottery, won over fifteen regional and state awards. She has pieces in five permanent collections and twelve private collections. Lisa was also featured in the Craft Report and Pottery on Tour as well as "Arts Across Kentucky" and "Clay Times".

As if these were not enough accomplishments, Lisa was a professional writer from 1975-1981 and this talent included being a technical writer, copy writer and editor, as well as a free-lance writer for Kentucky periodicals. Lisa was a college and secondary instructor in English and composition from 1971-1975 and an instructor in ceramics at Belleramine College from 1988-1992.

Lisa says, ""I love the idea of encapsulating a moment in time with objects, words, and images: whether it is an emotion, a social commentary, a piece of history, a person, or a place. To capture that moment and to keep returning to it because it evokes a feeling is my purpose in making mixed media. I want the viewer to think about the piece, have feelings about the piece, and to make art part of the collective experience. It is leaving a piece of time and our world behind in its physical form as well as in memory."

Her work achievements are as follows: **Galleries** Pyro Artists Cooperative Gallery. Louisville, Ky. 2004-2007.

Exhibits "Faces of Women International Juried Art Exhibition". New Mexico Museum. Las Vegas, New Mexico. 2007. **Honorable Mention.** "All It Takes For Evil To Prevail". Pyro Gallery installation. 2006. "OH + 5". The Dairy Barn. Athens, Ohio. 2006 LAFTA Show. Kentucky Museum of Arts and Design. 2005, 2006. "Precious Little": An Exhibit of Keith Lo Bue and His Students". Studio 9. Chicago, Illinois. 2005. "52 Mid-States Art Exhibition". Evansville Museum of Art, History and Science. Evansville, Indiana 2004. "Tramps, Vamps, and Vixens: A

Tribute To Bad Girls." Solo show. Pyro Gallery. 2004. "The International Exhibition of Collage and Assemblage Artist". Gallery 24. Berlin, Germany. 2004 " Mask of Creativity". Carnegie Center for the Arts. June 2004. "The Language of Art". Artopia Gallery. 2003 " Four Shadowing". New Member Show. Pyro Gallery. 2004. "280/PARAMETERS: A Regional Juried Exhibition of Fine Contemporary Art." Huntington Museum of Art. Huntington, West Virginia. 2003. "Expression of A Lifetime". Lexington Art League. 2003. "An Early Times Sampler". Kentucky Arts and Craft Gallery. 2003. Towers" Louisville Visual Art Association. 2002.

She has received the following scholarships and grants:
 Individual Artist's Project. Kentucky Arts Council. 2000. 2003.
 Scholarship to Quilt and Surface Design Symposium. 2000. 2003.

Her Bibliography includes the following:
Studio Zine recipe book. Mixed media artists. July 2001.
Featured on "Mixed Media" KET2. 2002.
Featured in Summer 2003 Gallery of ArtiTude Zine.
Featured Artist of the Month. Propensity.com. February 2004.
Today's Woman: "When A Potter Can't Make A Pot". May 2004
Louisville Magazine: "Artists and the Old". July 2004.
"Hold Everything: A Study in Adhesive and Clamps". Artitude Zine. Summer 2004.
"A Journey of Mixed Media". Arts Across Kentucky. Fall 2004.
Contributing Writer to Arts Across Kentucky. 2005-present.
The Southern Registry.com (nominated by the Kentucky Arts Council for inclusion.) 2007.

Her commissions include work for Ms. LeRaye Bunn and Ms. Sarah Yates

 Lisa is a Member-at-large: Louisville Area Fiber and Textile Artists. 2000-2005.
She is also a juried participant in Kentucky Crafted, a marketing division of the Kentucky Arts Council. 2004-present and was the secretary of the Pyro Cooperative from 2004-2005 and the exhibitions coordinator. 2005-2007.

Her works are all "one of a kind" art pieces and the average size is 16" x 20" with prices starting at $75.00 and going to $1,000.00.

Lisa Austin welcomes all visitors to her studio at 237 Fairfax Ave. Louisville, Ky. 40207
www.laustinmixedmedia.com 502-893-3836 lpaustin@bellsouth.net.

Who's Who Kentucky artist Donna Williams

Donna J. Williams, eldest granddaughter of Brother Winford Smith, has been "Followin' Family Traditions" since 1988. She is honored and blessed to be "Followin' Family Traditions" of the Hawkins and Smith families of Hart, Grayson and Edmondson Counties of Kentucky.

Donna J. Williams is a native of Grayson County and currently resides in Henry County with her husband Ray. Their son, Daniel who resides in Woodford County is the seventh generation of family broom-makers. Donna says, "All my brooms are hand made with real broom corn. Each broom is unique; all are made with care to quality construction. "Paw-Paw" taught us that way, and we each had to demonstrate our technique and craftsmanship were up to his strict standards.

She became the sixth generational broom-maker within a long lineage of family broom-makers. Documented broom-makers in her family are: Great-great-great Grandfather William Jasper Hawkins or his wife Elizabeth; Great-great grandmother Mary Jane Morris Hawkins; Great uncle Lee and Great aunt Pauline Hawkins; Brother Winford Smith and Nadine Smith Vincent of Hart, Grayson and Edmonson Counties of Kentucky.

Donna says, "I began making brooms after watching my grandfather, Brother Winford Smith, of Hart County. Brother Smith learned how to make brooms from watching and helping his grandmother Mary Jane Hawkins, Uncle Lee and Aunt Pauline Hawkins. I began a five-year apprenticeship with my grandfather in 1988; I then embarked on my own broom-making ventures of demonstrating primarily at historical re-enactments. In 2000 *"Followin' Family Traditions"* the business, was created."

Donna makes traditional brooms according to the methods used by family members. Kentucky broomcorn is preferred in her brooms, when it is available. Her grandfather grew all his own broom corn as did the other members of her family who engaged in this art. However, the past 4 or 5 years has been bad for Kentucky broom corn and she has to rely on outside suppliers such as Mexico. Her favorite is from Hungary as the broom corn is grown under similar conditions as Kentucky which makes the broom corn heavy and reddish in color. Now some sort of revolution in that country has currently cut off her supply. Her brooms are designed on a variety of handles: standard handles or "common handles" are purchased from her broomcorn supplier; twisted branches or tree limbs with unusual shapes are the ones she has the most demand for so she locates "forages" in nearby woods, or on farms; hand-forged iron handles are specially designed and purchased from various members of the Kentucky Blacksmith Association.

Donna created and conducts simple easy broom-making classes with area 4-H groups and schools. She loves working with the kids. In 2002 the Kentucky Craft Marketing Program juried her brooms into the program, after fourteen years of making brooms; she was very honored, not only for herself but also for her grandfather Brother Winford Smith and other family members. Each broom proudly bears the special "Kentucky Crafted" logo, which is attained only through the Kentucky Craft Marketing Program. This year (2007) Southern Artistry gave her the prestigious honor of being one of only 50 artists chosen by them for the state of Kentucky.

Donna's brooms start at $3.00 and go to $65.00 and her dolls and horses which she has been making since 1979 sell from $9.00 to $25.00. You can call her at 502 845-4227 or best email her at kybroomlady@iglou.com to order your own Kentucky broom or doll. Her current website is www.kybroomlady.com

Who's Who Kentucky artist Joanne Hobbs

This isn't about Horse Feathers! This is about Goose Feathers! Did you know that only the goose feathers from the tails and wings of a goose can produce a feather to work into a Christmas tree? The rest of the goose only produces down feathers. I did not know this either until I interviewed Joanne Hobbs of Bardstown, KY.

Joanne is a native of Dodge City, Kansas, and was raised in San Antonio, TX. She lived off and on in KY until she finally settled in Bardstown in 1980 where she has the Homestead Bed and Breakfast.

Joanne is a self-taught and has been crafting German Reproduction Goose Feather Christmas Trees, Ornaments, and Feather Fences for over twenty years. She belongs to the Kentucky Craft Marketing Program and was a featured artist at "Kentucky Spirit - Naive Exhibition" at the Owensboro Museum of Fine Art, as well as, at the Appalachian Arts Council's "American Log House" exhibition at the 2006 Home and Gardens Show in London, England. Her trees can be found in historic homes and galleries across the country and have been shipped throughout Europe. A

five-foot version of her tree was selected to stand center stage at the Santa Fe Opera House during their run of a German opera. You can reach Joanne at 502 349 1777 to order one of these trees.

It is no piece of cake making one of these trees. The quill feathers, which she buys commercially, are stripped of their feathers by Joanne and then washed, dried, trimmed, dyed and then wound onto the tree limbs and trunk and then the tree is assembled by Joanne. A 19" tree takes Joanne about a day and a half to make, provided there are no interruptions. The trees are made in various sizes and costs. 12" $52.50, 19" $82.50, 28" $127.50, the most popular is the 36" at $187.50. A 4 ft. tree is $400.00, the 5 ft. tree is $500.00 and the 7 ft tree is $1,200.00 and takes a lot of time and effort to make it!

She also makes goose feather ornaments that are sold for $15.00 each and she has just started making goose feather fences to put around the trees and they go from $50.00 to $135.00. The ornaments shown on the tree in these pictures are made by her friend Ornaments by Lewis Newman of David, KY.

Joanne does workshops/Retreats, Festivals/Trade shows and she demonstrates workshops both at the Kentucky Artisan Center in Berea, KY and the Kentucky State Fair. Photo credits: Gwen Heffner/Kentucky Artisan Center

Who's Who Kentucky artist Steve Hovious

Scroll saw art is a delicate art that takes lots of patience and there is a fine line between scroll saw fine art and firewood art.

Steve R Hovious is a self taught scroll saw fine arts artist who took up the art as a hobby after he became ill in 2002. A native of Phoenix, Arizona, he grew up in Paragon Indiana. After graduating high school in

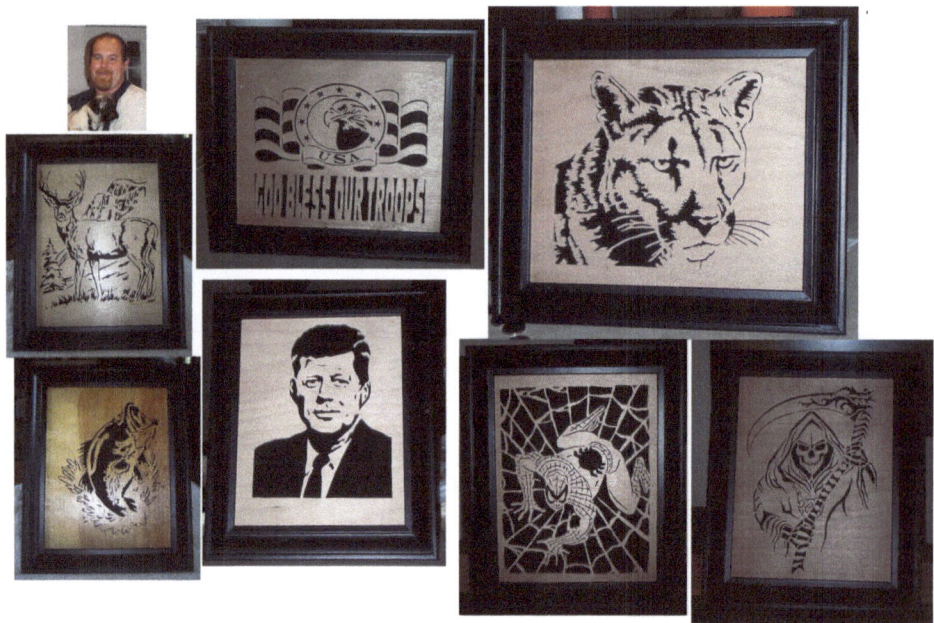

1982 Steve enlisted into the National Guards and had a 20 year career as a pump Master until his illness. After becoming ill Steve and his wife moved to Columbia Kentucky in December 2006.

Over that winter he started researching the arts and crafts area on the internet to see if there was something he was capable of doing with his medical problems. Steve discovered the scroll saw and a couple easy projects. He started doing more research on the scroll saw and its capabilities and signed up with several Scroll Saw Forums.

By February 2007 Steve had totally convinced himself he wanted to do this and he purchased his first scroll saw, materials, and supplies for under $200 and gave it a try. In no time Steve found it very addictive and lots of fun. He says, "Each and every piece that gets finished just adds fuel to the addiction of wanting to do more. I have posted my work on the forums I belong to and receive several great compliments on them. I am also learning to make patterns for these cutting as well."

The picture with god bless our troops was from one of Steve's patterns he designed. Of the other pictures of his cuttings Steve says, "I need to give RC Mitchell, Honey, ARPOP, makinsawdust925, Revscott, and NCscrollsawer the credit for their contribution of the patterns and many thanks as well."

Finally Steve felt ready to take the plunge in the fine arts world and in June of 2007 he entered a piece in the Open arts category called Mule Deer in the Adair county Fair. It received a first place ribbon. Steve has been using ¼" Birch or Oak Plywood for his cuttings. He makes the majority of them as an 8" x 10" portrait and he lines the back with felt, finally putting them in a picture frame. Steve has created a site where everyone can view his work along with the materials and credit to the pattern maker: http://hovious.blogspot.com/. Steve's E-mail address is shovious@windstream.net if you would like to contact him about purchasing his work or having him make something special for you.

Who's Who Kentucky artist John Raymond Leeds

In Richmond KY there is a jewelry artist named John Raymond Leeds who has taken the art of jewelry making one step further by making exclusive one of a kind pieces of jewelry using many unique things including Kentucky agate. John is more than a jeweler; he is a goldsmith, artist and designer.

John says, "my objective is to exhibit and share my art with my fellow artisans by creating more handcrafted one-of-a-kind jewelry that I present at the art shows that I attend and I hope to gain a better business and further my ability to design and craft more choice pieces."

He attended Eastern Kentucky University and graduated in 1995 with a Bachelor in Art. He also was trained in jewelry by Tim Glotzbach at EKU, trained in printmaking by Don Dewey and studied in Florence, Italy under Tomaso Fuji

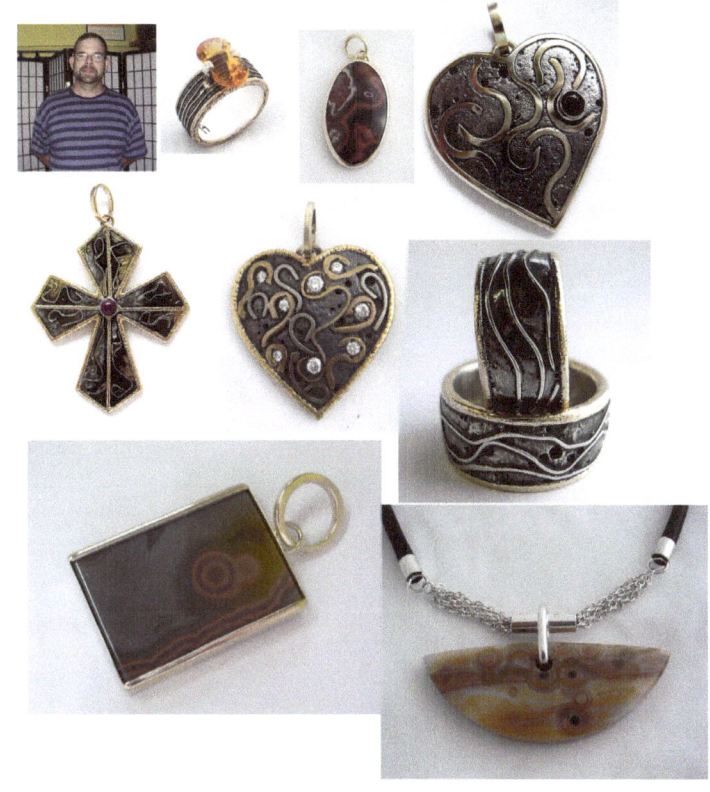

John has operated and owned a retail and custom shop since 1991 where he provides retail and wholesale repair in addition to creating original jewelry either through either his own design or the customer's design. John can also provide casting of jewelry in his shop. He is a juried member of Kentucky Guild of Artisans, Kentucky Craft Market, Exhibiting Member of The Guild of Artists and Artisans, Member of the Ohio Designer Craftsmen and Craftsmen Board Member.

John's recent exhibits include: Kentucky Craft Market, March 2005, 2006 and 2007 Kentucky Crafted: The Market's 25th Anniversary, Orsam Sylvania Designer Showcase Participant, Kentucky Guild of Artisans and Craftsmen Shows since 2000, Annual Capital Expo Festival, June 2006, Award Winner Holiday Fair, November 2006, Tucson Gem Fair 2007, Elmhurst Art in the Park May 5-6 2007, Elmhurst, IL, Berea International Fair May 17-20 2007, Berea, KY Arts on the Green June 2-3 2007 LaGrange, KY Award Winner, Second prize in wearable and Francisco's Farm
June 16-17 2007 Midway, KY

John keeps busy with many projects which include his Acid Etched Collection, crafted by using 14K, fine silver and alloy, his Kentucky Agate Line, cutting and designing jewelry from Kentucky's state mineral to create distinctive and matchless jewelry that displays the beauty of the Kentucky Agate, cutting and polishing stones that feature unique markings and creating distinctive pieces of jewelry, whether custom projects or own works

 He can be reached at 108 East Main Street , Richmond KY, 40475 Phone: 859.624.4200
Email: jleedsgold@aol.com Website: www.jleedsjewelry.com

Who's Who Kentucky artist Mike Angel, Chair Maker

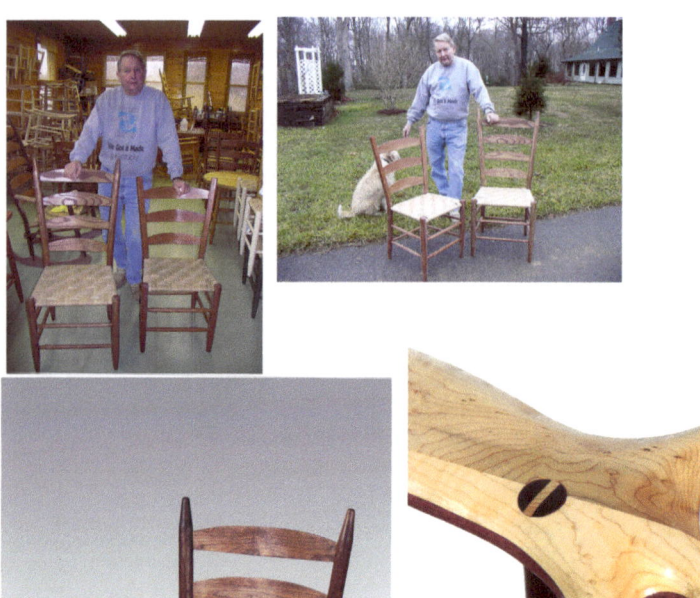

There is a beauty in wood that can only be found when someone like Mike Angel knows how to make that beauty show though in finely hand crafted furniture. Mike says, "Maybe it's due to my Kentucky roots, or my interests in vintage objects and woodworking, or the challenge of building a quality product, or just an excuse to sit and chat with fascinating folks from all walks of life. Perhaps it's a combination of all these reasons that I find great pleasure and satisfaction in handcrafting traditional Kentucky furniture. "

He goes on to tell me that it all began with a gunshot wound to his leg in 1987, while working on a drug raid as a Special Agent for the Bureau of Alcohol, Tobacco and Firearms (ATF) in Cleveland, Ohio. This led to three-year recuperation at his parents' home in London, KY, where, looking for a project to pass the time, he started restoring several hickory-bottom "mule-ear" chairs that were originally made by his grandpa "Poppy" Joe Hall. His interest in actually constructing such chairs grew as I visited old-time woodworkers in eastern Kentucky to study their techniques. Soon he was collecting vintage - as well as power - tools and machines with which to practice his craft, and by the time he officially retired from the ATF in 1994 and relocated to Kentucky, Red Dog & Company was born.

Through the years since then, Red Dog & Company seemed to take on a life of its own, continuing to expand in size of operation and numbers of proud owners of our products. Mike's reputation for well-built, comfortable, handsome furniture has found its way across the country and Canada, often by word of mouth, but also through articles in publications and displays at various craft shows and in five regional galleries. Currently, Mike is a member of four juried guilds, including the Kentucky Guild of Craftsmen and Artists. His furniture is owned by many corporations, institutions, and several well-known people, including the former U.S. President, George H. W. Bush. As demand for his furniture increased, so did the volume of work. This allowed him the opportunity to engage as many local artisans as possible, such as assistant woodworkers, chair weavers, and wood carvers. Family members also help out, particularly his wife Fredi Angel, who does the hand finishing and handling inquiries, sales, and shipping. Also, his sister Ann Eberhardt, a professional artist, hand paints images on specially ordered chair slats and solid benches.

Besides the Kentucky mule ear chair, the Red Dog line also includes rocking chairs, captain's chairs, settees, benches, stools, and side tables. Mike specializes in the traditional Kentucky rocking chair, custom made with a woven seat and his signature handholds. Mike says, "The idea came to me when I noticed that people who were trying out my rockers would roll their fingers over the ends of the arms. With my unique design, they can comfortably interlace their fingers with the "fingers" of the handholds ". Mike uses the green wood technique, which takes advantage of the natural movement of wood during the drying process. This method, used for centuries, is based on the fact that wood shrinks when it dries. He manipulates the moisture content in the tenons and mortises. The tenon is dried to a lesser moisture content than the mortise; thereby a tight joint is created. Theoretically, glue is not necessary. Wooden pegs are used in lieu of metal fasteners. Mike enjoys coming up with new designs and wood combinations to keep the furniture line fresh. He purchases Kentucky native ash, oak, cherry, and walnut by the log and have it custom cut at a local mill. Mike occasionally uses special-order exotic woods, such as wormy chestnut, burled mesquite, purple heart, and Osage orange which, after exposure to light, changes from bright mustard yellow to a very appealing deep warm honey.

Mike says, "My mission is to continue the Appalachian tradition of making furniture with one's own hands, so that people who appreciate this time-honored skill can own a one-of-a-kind work that they will treasure and that will stay in their family for generations. "

For more about Red Dog & Company you can visit our website at www.reddogchairs.com or you can email him at mike@reddogchairs.com, or call him at 606-878-8555.

Who's Who Kentucky artist **Maryanne Brown Mize**

Pottery takes all forms especially in style, design and color. Each potter/artist develops his or her own style, design and colors and award winning potter/artist Maryanne Brown Mize of Lawrenceburg, KY proves the point.

Maryanne says, "I had my first experience with clay when I was 8 years old. From then on I was hooked. I tried other more traditional ways of making a living but none held my attention like clay. So, in 1996 I took the leap and quit my "real job", moved to Kentucky to be closer to family, and started being a full time potter. I have never looked back. My husband and I built a studio behind our house, then a kiln and also a forge (my husband is a knife smith). Potting full time has allowed my creativity and imagination to take off in new directions. Now, making a piece for you to pick up, use and experience is my dream come true."

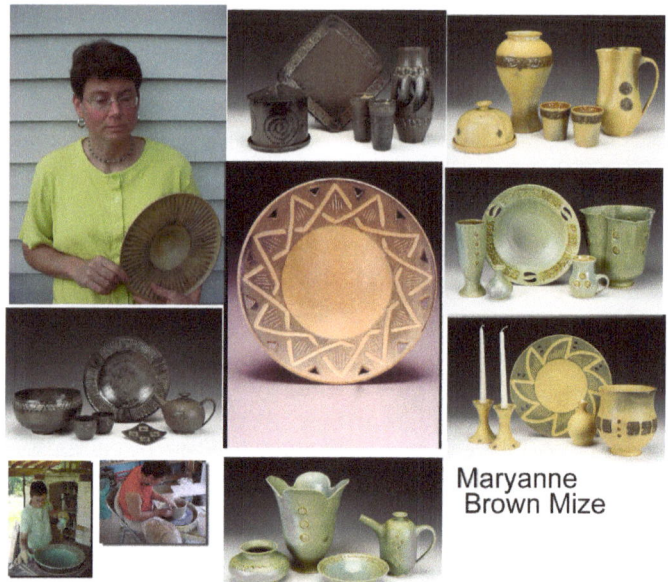

Maryanne
Brown Mize

Her style is Sgraffito which is defined as ("scratched", plural Scraffiti and often also written Scraffito) is a technique either of wall decor, produced by applying layers of plaster tinted in contrasting colors to a moistened surface, or in ceramics, by applying to an unfired ceramic body two successive layers of contrasting slip, and then in either case scratching so as to produce an outline drawing. A combed wall surface is produced by dragging a comblike tool over a prepared surface, producing stripes or waves.

Maryanne took a youth class at the Indianapolis Art League. By the time she was in high school had already done reduction, salt and pit firings, so the clay teacher let her help load the kilns. After high school she tried being a dental technician for a while, but clay was her true love. Maryanne says, "I started building my portfolio and looking around at collages with good art departments. For my freshman year I went to Tennessee Tech University in Cookeville. By the following September I had moved to Memphis and had transferred my credits. In 1989 I graduated with a B.F.A. and a major in ceramics. During the summer following my sophomore year I spent several weeks at Penland in NC. I could afford it only because of a program the school offered where I worked for the school in exchange for paying only half of the tuition. I was lucky and got the job of loading the kilns in the clay department. After graduation I started experimenting with porcelain and Mason stains. My fish series included bowls pieced together to create the image and vases carved with the sgraffito technique. But each piece was very labor intensive and I burned out on that series pretty quickly."

She goes on to say, "I then jumped to the opposite end of the spectrum and started firing Raku and throwing everything on the wheel. Not only did the method change drastically, but the inspiration did also. Architecture of any kind influenced the shapes I was throwing. That phase was even shorter then the fish phase because I rarely ended up with something I was satisfied with. Many pieces were lost due to the firing process.

Switching to stoneware was the answer. Throwing on the wheel was my true love and with stoneware I could make the functional ware that paid the bills and more sculptural pieces for my own sanity. By late 1990 I had become a juried member of Tennessee Association of Craft

Artists (TACA) and was doing my first arts and crafts show. For the next five years I kept my day job and worked in the studio at night."

Then in 1996 Maryanne took the big jump when she moved to Kentucky and started working full-time in clay. A year and a half later she was juried into the Kentucky Craft Marketing Program, and started doing art shows and exhibits through out Kentucky and the surrounding states. In 2001 she was juried into the Kentucky Guild of Artists and Craftsmen. At that time she had added one more facet to her work. The addition of the stamped texture was small at first, making the stamps from the same clay. The earliest ones were individual stamps, then to save time they became cylindrical in shape so the texture could be rolled onto the surface; and with time the stamps became larger and more intricate in design. Using the individual and rolled stamps together led to the cut –out decoration technique on more decorative shapes that are mostly thrown on the wheel. The soft colors of the glazes used are to accent the texture on each piece.

By early 2004 her work had made a full circle. Still working in stoneware she re-interdicted scraffitto to her work in addition to the stamped textures to decorate each piece. The patterns that she uses now are much bolder and less detailed then in the fish series but the process is the same. The designs that she uses in scraffitto on large wide bowls resemble some of the smaller stamps she uses on other work.

Maryanne is a member of the Kentucky Craft Marketing Program (KCMP), the Kentucky Guild of Artists and Craftsmen (KGAC) and the Ohio Designer Craftsmen (ODC).

Who's Who Kentucky artist Ken Gastineau

In Berea, KY there is a beautiful building that houses the Ken Gastineau Studio and in that studio is an amazing and beautiful array of jewelry designed by Ken Gastineau.

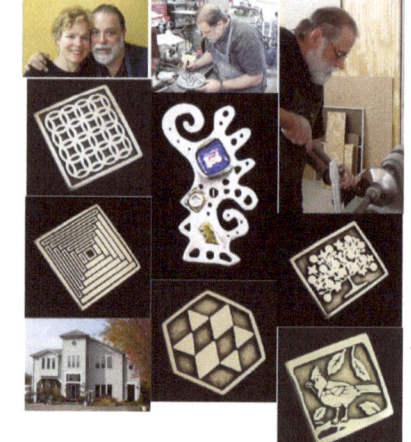

Ken and his wife Sally's life and work are totally intertwined. While traveling through Europe in 1976 Ken saw a craft show in Holland and he became impressed with the jewelry he saw, especially the simple lines influenced by Scandinavian silver work. Upon return home to Missouri he started working in a production jewelry shop and later moved to Colorado so he could spend time in the Rocky Mountains. A few years later he moved to Santa Fe, New Mexico and the exposure to the Southwest was an education in itself because Ken was now exposed to some of the finest jewelry in the world. He discovered a nearby sculpture foundry and that inspired his spark for exploring steel work.

He met Sally in Sante Fe, NM and she married him, quit her job and began to work with him. Sally is a native of Louisville, KY and in 1987 they moved to KY and settled in Berea.

Ken serves on the Berea Chamber of Commerce Board and is also the chairman of the Artisan Advisory Committee for the Board of the KY Artisan Center at Berea. He is also active in working with State government in Frankfort to help implement the SED plan as concerns the arts and crafts in KY. As a result of the states strong efforts in marketing crafts, Ken's jewelry was included in Phyllis George's first QVC craft program, "Kentucky Crafted", in June 1992.

His pewter castings are lead free and most of his designs have roots in Kentucky. Ken has won many awards and his exhibits and Commissions are too numerous to mention here.

You can see his products at Gastineau Studio, 135 north Broadway, Berea, KY, 859 989 9158 or email ken_gastineau@gastineaustudio.com

Who's Who Kentucky artist is Suzy Hatcher

Pottery making is really gratifying and is a time honored and one of our earliest arts and crafts. Much of our world's history can be recorded in pottery found in archeological digs.

Suzy Hatcher of Louisville is an accomplished potter and we add her to our growing lists of Kentucky's fine artists. Suzy Hatcher received her Bachelor of Arts, Studio Art in 1993 from Hiram College in Hiram, Ohio. In 1997 she received a Master of Arts, Ceramics from the University of Louisville, Louisville, Kentucky.

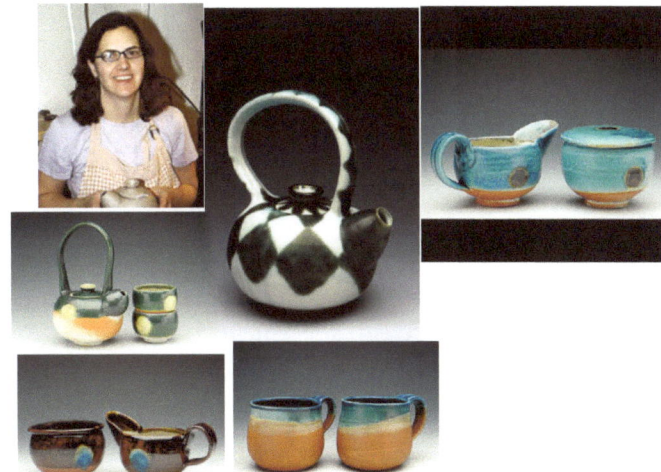

Suzy is primarily a studio potter, but she also teaches pottery at her home studio where she offers regular classes for children, teens, and adults and in the Louisville community as a guest artist. Active in the local arts community Suzy has worked hard to bring her love of ceramics to people of all ages.

This past winter Suzy worked with elementary children at Bloom in the Highlands neighborhood of Louisville. She taught the students how to create coil pottery and self portrait tiles. She will again be an artist in residence there in January and February in 2008 working with art teacher Melinda Snyder.

Her personal work is utilitarian, from cream and sugar sets to chip and dip bowls to teapots. Suzy utilizes a soda fired gas kiln to accentuate form and highlight the surface of her beautiful ware.

Her creations can be found at Lionheart Gallery, the Kentucky Museum of Art and Craft, the Kentucky Artisan Center, Artifacts in Indianapolis, and Hidden Hill in Utica, IN.

Suzy will accept commissions and orders from individuals and small businesses. She is a juried member of Kentucky Crafted which is sponsored by the Kentucky Arts Council. Her website is http://www.suzyhatcherpottery.com or you can call her more info at 502 895 7735

Who's Who Kentucky artist is Melvin Rowe

Melvin Rowe, often referred to as the "Colonel of Clay" is an integral part of the Kentucky ceramics world for more than 30 years. He loved creating as a child and says," I'd make things out of whatever I could get my hands on: oatmeal boxes, coat hangers, scrap wood."

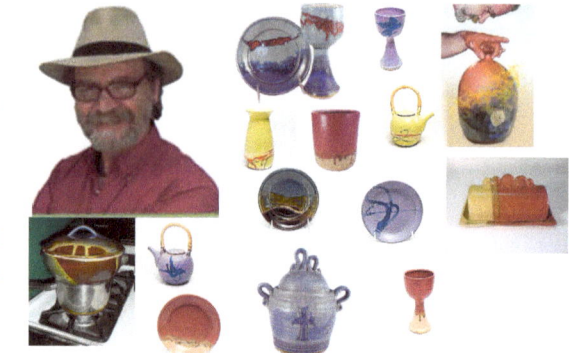

Melvin entered Western Kentucky University to study fine art to become a cartoonist, but upon taking ceramics became hooked on that instead. He earned his B.F.A. at WKU and his M.A. in ceramics at the University of Louisville. "It's 35 or so years later, and I still can't wait to open the kiln, to see the new stuff, the new experiments," he says.

Melvin worked full-time, including serving as director of Metro Arts Center in Louisville, and also taught part-time and still was able to produce his own work. In about 1981 he was offered a job in Montana, but he chose to stay in Louisville to become a full-time production potter. He knew he would be better with the material if he threw 100 mugs a day rather than creating a space for others to do that.

In the 1980's Melvin operated retail venues first in Bakery Square and then on Frankfort Avenue, where he has lived and operated his studio and shop ever since. Direct retail is about half of what he does. The pottery has a lot of repeat customers. Some have been coming for over 25 years and have become good friends. He makes chargers, plates, goblets, strainers, steamers, bowls, tea pots, butter dishes and much more which you can see by going to his website
http://www.potteryrowe.com

One can buy Melvin's pottery for their business as he also sells his work through wholesale and specialty accounts. Melvin's diverse accounts include making religious vessels for churches and mugs for local bars. "Flanagan's on Baxter--- I've made over 500 mugs for their mug club," he says. He also makes the mugs awarded to prize winners in the home-brewed beer competition at the Kentucky State Fair.

As a wine maker, wine carafes and decanters are among Melvin's favorite items to In 2006 he won a first place ribbon at the Kentucky State Fair for his Colonel Mel's Green Apple Honey Mead At this year's fair he won a third place ribbon for his Heap Big Medicine Mouthwash and Pain Killer. Melvin's great sense of humor spills over into his wine labels.

Melvin says there is a similarity between making wine and ceramics. "The chemistry of wine making is similar to glaze chemistry," he says. "You have to understand the ingredients and what something is going to be after going through the process."

All his pieces are ovenproof, dishwasher safe, non-toxic and microwavable and every piece is formed by hand on the potter's wheel. His colors and glazes are brilliant and he will make up special colors for special orders. So the next time you are in Louisville, stop in at Pottery Rowe at 2048 Frankfort Ave, Louisville, KY 40206. 502-896-0877 email
MelvinRowe@PotteryRowe.com

Who's Who Kentucky artist is Ken Roberts

There is nothing fishy about the work of metal artist Ken Roberts.

Born and raised in Kentucky Ken received his education and graduated from Michigan State University with a BA in studio arts. Ken began a career in commercial art.

He has worked as an Art Director, Designer and Illustrator and has spent time in Indiana, Ohio and Michigan before moving his family to California.

Ken spent twenty years working in California as a designer and illustrator for many of the top advertising agencies. The work was rewarding and fulfilling, but hectic. That's when he decided to simplify his life and move back to Kentucky. Ken says, "I just wanted to get away from the deadlines and become my own client." Moving back to Kentucky and building a home on Lake Barkley seemed the right solution.

This move gave him the opportunity to do what he always wanted to do which was to become a fine artist. He still does an occasional illustration for advertising or publishing. Ken still does a weekly cartoon for Copley News called "Everybody's Business." He says, "It lets me keep my hand in the business that was very good to me for so many years."

Ken also does cards and many "one of a kind" items and does commission work.

Ken and his wife Sandy have two daughters and four grandchildren. They have all relocated to this area of the country. "It makes things a lot more enjoyable to have the family close."

Ken Roberts work can be viewed in galleries in Paducah Ky., Hopkinsville, Ky., Berea Ky., and Nashville Tennessee. Hs work is in collections throughout the country.

His website is http://www.kenrobertsonline.com/

Who's Who Kentucky artist is John Neel

It's exciting to meet a prolific painter and it's also more exciting to meet one who is self taught and still going strong in his mid eighties. Meet John Neel of Bonnieville, KY who qualifies on all fronts.

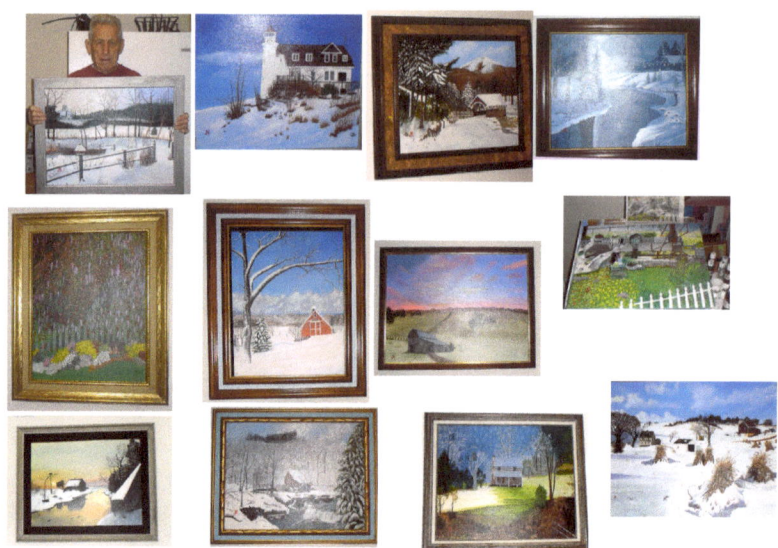

John is a brick mason turned painter about 1992 when he started to take care of his invalid mother. He told his wife Bea, that he was going crazy with boredom and to bring him something to do while he was over caring for his ailing mother at her home. Since John used to watch Bob Ross on TV and since Bea had some old oil paints from a workshop she took a long time ago, she brought all this stuff over to John. However, they discovered the oil paints were so old they had dried up and Bea scurried over to an arts and craft's store and picked who what she thought was an oil painting kit. It turned out to be an acrylic painting kit and John fell in love with acrylics and has been painting up a storm ever since.

Bea has tried to get him to use oils, but John says they are too slow for him. He loves the speed of the paint to say nothing of the scope he gets from them. John is basically self taught and later on he and Bea took one Bob Ross workshop. However, as far as this writer is concerned he need not have bothered. John has good style, perspective and composition. He mostly paints from photos he has taken or photos he has seen that capture his eye.

Their home is virtually an art gallery with every room filled with his wonderful paintings and what is not framed and hung is stacked up in boxes. I asked John if he would sell any and I received an emphatic no! However, John is going to consider selling some signed and numbered prints and also some greeting cards and post cards that will be suitable for framing.

Arlene Wright-Correll is the resident artist at Avalon Stained Glass School in Munfordville KY and she offers her famous **"The Cheap NO Talent Needed©" Art Series ©These wonderful little workshops are designed for those of you who always wanted to try their hand at art, admired art and always say,** *"But, I can't draw a straight line!"*. **Well, you do not need to know anything including the** *"straight line"* **bit.** *NO more excuses.* **These are fast, fun, cheap; include all your materials and then you can decide whether or not this hobby will be worth pursuing. What better way to spend your time, meet new people, learn something new and get away from the house, family, TV and get into a space of your own. Well here it is! Only $25.00 bucks! No more excuses. Sign up today! Registration limited to 6 students 13 yr old and up. Call Avalon Stained Glass School (270)524 9567, Munfordville, KY 42765**

http://www.learn-america.com/stories/storyReader$1544

She will even bring those courses to your art group within 150 miles of Munfordville, KY for that low price per person provided there is a minimum of 10 students.

Call and set one up today!

In 2008 she will also be teaching fused and slump glass workshops. Call for dates.

Check out all our Avalon Stained Glass School Workshops and make your next vacation a learning vacation.

http://www.learn-america.com/stories/storyReader$1984

Arlene is currently working on the **2008 edition "Who's Who in Arts and Crafts©"** and she says this year she is not limiting it to only Kentucky artisans and crafters. She invites all to send her information by clicking on the following link.
http://www.learn-america.com/stories/storyReader$2759

You can check out Arlene's other books at http://stores.lulu.com/kate1031

When you buy one of Arlene's books, cards or art you are helping combat cancer in children. All Arlene's royalties go to the St. Jude Children's Research Hospital and she thanks you for buying this book and her other works.

www.ingramcontent.com/pod-product-compliance
Lightning Source LLC
Chambersburg PA
CBHW051055180526
45172CB00002B/644